Larousse
Animal Portraits

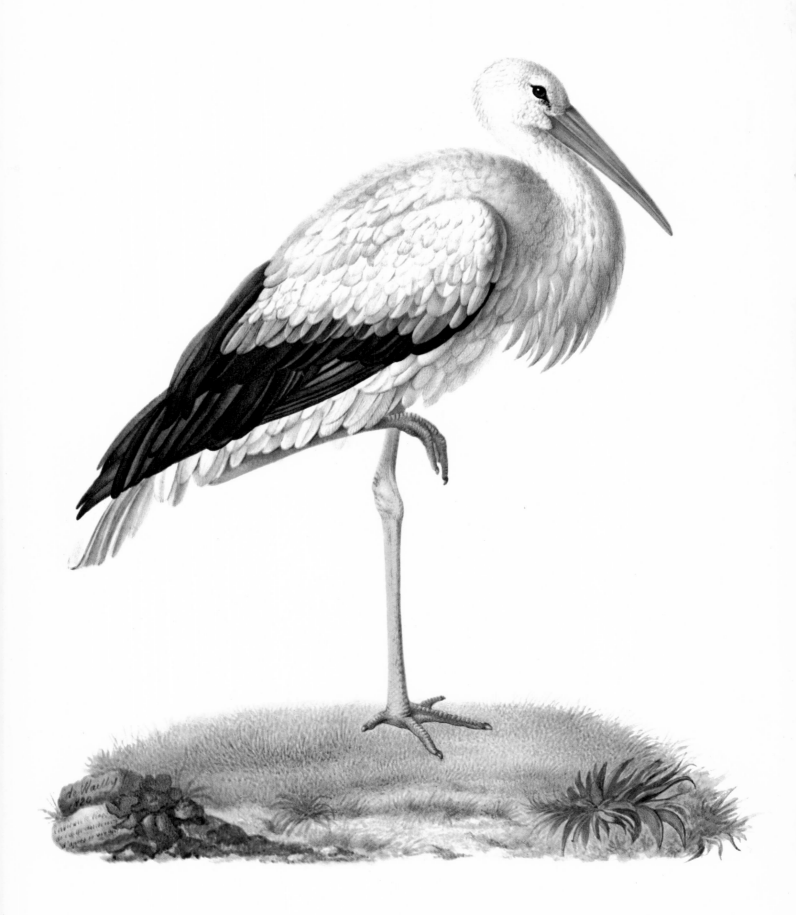

Larousse
Animal Portraits

P. P. Grassé

Consultant Editor Dr Maurice Burton

Larousse and Co., Inc., New York

Translated by John Bailie

First published in France by Librairie Larousse under the title
Le Plus Beau Bestiaire Du Monde by P. P. Grassé

First published in Great Britain by
The Hamlyn Publishing Group Limited
Astronaut House, Feltham, Middlesex, England

ISBN 0 600 35507 1

First published in the United States by
Larousse and Co., Inc.,
572 Fifth Avenue,
New York, N.Y. 10036

1977

ISBN 0-88332-076-2

Library of Congress Catalog Card No 76-52344

Phototypeset by Tradespools Ltd, Frome, Somerset
Printed in England by Alabaster Passmore & Sons Ltd.

List of Plates

Introduction

Our original intention was to reproduce the works of great painters – such as Dürer, Géricault, Delacroix and Picasso – in which animals are the dominant theme. We gave up this idea because we could not reveal beauty without transgressing the laws of realism, and for this reason we have had recourse to those treasures of animal art gathering dust in libraries, buried in archives or in old books, of whose existence only a few people are aware. Many of the finest of these treasures are the property of the French National Museum of Natural History. I am referring to the admirable collection on parchment (more than 6000), on which miniaturists have ruined their eyes drawing and painting the portraits of animals or plants which naturalists gave them to reproduce.

The promoter and benefactor of these miniaturists was Gaston of France. A brother of Louis XIII, the third son of Henri IV and Marie de Medici, he has had an unfortunate reputation in history. An opponent of royal absolutism, the sworn enemy of the Duc de Richelieu, and unhappy ally of the Queen Mother, he was said to be a man of mediocre talents and of an indolent nature. Not being historians we are not obliged to appraise these judgments. However, we do know that Gaston of Orléans was an enthusiastic naturalist and a generous and shrewd patron.

He created a botanical garden at Blois, the development and care of which was entrusted to four scholarly botanists. The catalogue of this garden ran into three editions. Gaston of Orléans did not remain content with this; he decided that the most skilful painters should be employed to portray the rare animals and plants in his garden and his private collection. He recruited several artists and was able to engage the services of an exceptionally gifted miniaturist, Nicolas Robert, who worked for him from 1645 to 1660, when Gaston of Orléans died. Nicolas Robert (1614–1685) painted on sheets of parchment (vellum) of exceptional quality, using a little-known process which gives vivid, light and transparent colours which do not fade. He combined a sureness and delicacy of touch with an acute awareness of the natural attitudes of the animal he was representing. To ascertain the truth of this the reader has only to glance at the works of this miniaturist reproduced in this volume.

This Himalayan Jay is a subspecies of the European Jay (*Garrulus glandarius*) which is widely distributed throughout Europe. It is almost identical in both plumage and habits. Like the European Jay it inhabits wooded regions. From a lithograph by John Gould, in *Century of Birds from the Himalaya Mountains*, 1832.

At the time of the death of Gaston of Orléans the parchments completed by Nicolas Robert and a few other painters of lesser talent comprised five large volumes. They were bequeathed as a legacy to Louis XIV, Gaston's nephew and a patron of the arts. On the recommendation of Colbert, Nicolas Robert entered the King's service and in 1666 Louis created especially for him the office of Ordinary Painter of the Miniature. Robert held this position until his death. The miniaturist worked in close collaboration with the botanists of the Jardin du Roi and the zoologists of the Menagerie at Versailles. The parchments were submitted to them for inspection so that their accuracy could be verified. Colbert, who was a great admirer of Nicolas Robert, had those parchments which he considered the finest copied by the pupils of the miniaturist. In this way he assembled an important collection in which several original works by Nicolas Robert appeared. In 1683, at the time of the death of Louis XIV's chief minister, the collection consisted of fifteen volumes, ten dealing with botany and five with zoology. After having changed hands several times in 1728 it was sold by Charles Colbert, Comte de Seignelay, an unworthy descendant of Colbert, to Prince Eugene of Savoy and taken to Vienna where it is now kept in the National Library.

The collection of Gaston of Orléans was housed, while continuing to grow, in the Library of the King at the Hôtel de Nevers. It was not until 1793 that it was assigned and transferred to the Museum. A provision made by the King was intended to ensure that this unique collection should be preserved and enlarged. At first ordinary painters of the King and then painters holding a chair in iconography continued the work of the early miniaturists. However, after the Jardin du Roi had been turned into a museum the chief task of the master iconographers was to educate and train artists capable of reproducing plants and animals exactly, above all those which were studied by the professors at the Museum. The treasures of this splendid collection, reverently preserved in sealed glass cases, are unknown to the public and have been seen – with special authorization only – by the few book-lovers who visit the National Museum of Natural History. It seemed to us that from this wealth of material a bestiary of exceptional quality could be made. After encountering many obstacles and making numerous approaches, we were granted permission to reproduce several of the chief works of this national treasure.

In this volume, the work of the great miniaturist Nicolas Robert can be generally appreciated for the first time. This artist seems to have led a simple, uneventful life about which we know little. He

was born in Langres where his father kept a hotel. His first work was a collection of engravings published in Rome in 1639 under the title of *Fiori diversi*. Then came his illustrations for *La Guirlande de Julie* (1641) which established his reputation. In 1670 the painter returned to engraving, to which he devoted himself almost exclusively, and collaborated in a great work undertaken by the Academy of Sciences; a general history of plants with illustrations of all the species described. Other talented engravers collaborated in the creation of this ambitious project, notably Abraham Basse. Nicolas Robert's sketches in red chalk, reproduced in the plates of the *Recueil*

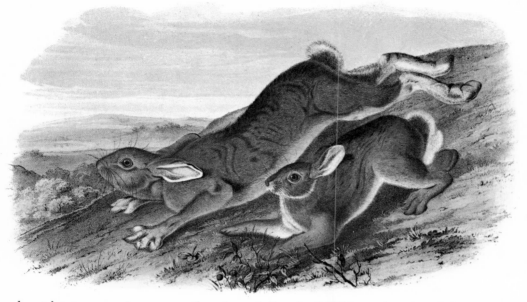

des plantes gravées par ordre du roi Louis XIV or in the *Mémoires de l'Académie des Sciences*, are inserted in the collection of parchments and form alone two ample volumes.

The successors of Nicolas Robert were not as gifted as he was. Some of them were excellent miniaturists but since they painted only plants it is not appropriate to mention them here. However, some reference should be made to Pierre-Joseph Redouté (1759–1840), the remarkable painter of roses. Among the painters of animals we must mention briefly Jean Joubert (1643–1707), who painted mainly plants, but with considerably less skill than his predecessor. After him, in chronological order, come the following: Nicolas Maréchal (1753–1802); Henri-Joseph Redouté (1766–1852), the brother of the painter of roses, whose favourite models were fish; Nicolas Huet (c 1770–1830), who possessed outstanding gifts – his parchments are among the best in the collection of the National Museum of Natural History; Pancrace Bessa (1772–1835?); Paul-Louis Oudart (born 1796); Léon de Wailly, to whom we are indebted for some remarkable engravings (painted from 1803 to 1824); Alfred

This plate showing two Varying Hares (*Lepus americanus*) running is one of the finest executed by John James Audubon in his famous book *Quadrupeds of North America*, much sought after by collectors. The Varying Hare changes its coat according to the seasons. In summer it has brown fur which merges with the colour of the earth. In winter it is white with only the tips of the ears black. It is very necessary for this animal to blend with its background of snow or earth, since it has so many enemies lying in wait for it. In the far north, where it is very much at home, the Lynx (*Lynx canadensis*) is its worst enemy. Its young are attacked by eagles and the Snowy Owl (*Nyctea scandiaca*). In New England, New York State and several other states its most formidable enemy is the Great Horned Owl (*Bubo virginianus*). Every day the young hare increases its weight by about 10 grams (0·35 ounces). It likes wooded, damp, even marshy, regions. It is of medium height (45–50 centimetres, 17·5–19·5 inches). Lithograph from *Quadrupeds of North America* by John James Audubon and the Reverend John Bachman (1849).

11

Riocreux (1820–1912), who drew sponges and madrepores with remarkable skill; and Jean-Charles Werner (1826–1857), who produced some magnificent paintings of mammals on parchment.

Towards the middle of the nineteenth century the naturalists were pursuing their studies in greater depth and becoming less interested in 'portraits' of animals. From this time onwards the collection of parchments was scarcely added to at all. Among the miniaturists of this period the only one worthy of mention is Adolphe Philippe Millot (1857–1921), two of whose plates, portraying insects, are reproduced here. At the end of the nineteenth century the Museum's collection of parchments, the finest and richest ever devoted to the portrayal of plants and animals, had virtually ceased to grow.

This book would have been incomplete without the addition of several examples of the finest watercolours taken from works on natural history. Among the great illustrators of animals were some who were at the same time travellers, explorers and naturalists. Three of these were exceptionally gifted: Maria Sibylla Mérian, John James Audubon and John Gould.

Maria Sibylla Mérian, who belonged to a family of Swiss painters, was born at Frankfurt in 1647, dying at Amsterdam in 1717. She very early showed a keen interest in, and a remarkable natural aptitude for, painting. She received lessons from the great painters, in particular Abraham Mignon, who taught her the art of miniature. She contracted an unhappy marriage with a painter from Nuremberg, who following a brush with the law fled the country, leaving her behind. Resuming her maiden name of Mérian and accompanied by her two daughters, she left for Holland where she became associated with the Labadist sect, many of whose followers emigrated to New York and Surinam. She was amongst the latter group and, with one of her daughters, made her way to this Dutch colony. There she remained for two years, devoting much time to drawing and painting her favourite subjects, insects and plants, to which she added reptiles and shells. She returned to Holland in 1701 and in 1705 published in Amsterdam her major work on the insects of Surinam (*Metamorphosis insectorum surinamensium*), illustrated with sixty superbly executed plates. Sibylla Mérian also left a most important work on the insects and plants of Europe; she was an accurate observer and was well acquainted with its flora and fauna. Her books are in great demand and are among the gems of any book-lover's collection.

John James Audubon was born about 1780 in Louisiana. His parents, of French origin, owned vast plantations. A gifted painter, he went to Paris to complete his studies. There, he was the subject

The Red Bird of Paradise (*Paradisaea rubra*) is one of the most beautiful if not the most beautiful of the birds of paradise. It lives in the Waigeo and Batanta Islands to the north-west of New Guinea. Only the male has a sumptuous plumage; the hen, which is smaller in size is a dull brown and yellowish colour, and has no crests on the head. The cock measures about 35 centimetres (13·5 inches) from the tip of the beak to the end of the tail. By Prêtre in Lesson's, *Les Oiseaux de Paradis*.

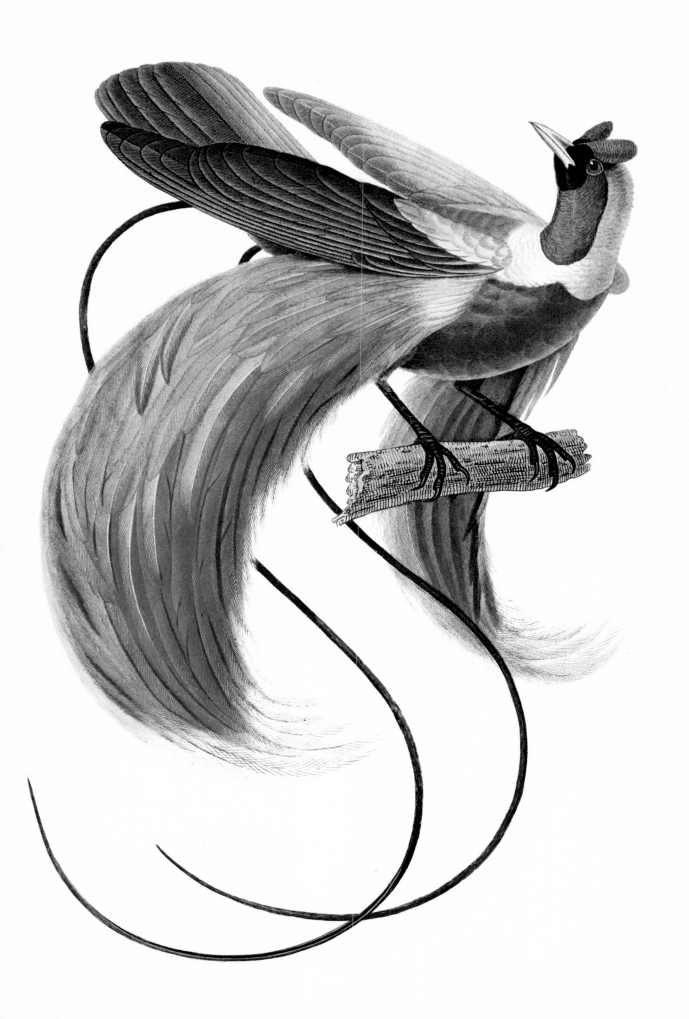

of a curious and absurd story: it was believed that he was the Dauphin Louis XVII and had escaped from the Temple prison. It has been suggested that this belief was motivated by the protection given to him by a certain Bernard de Marigny, a faithful royalist who was devoted to Louis XVI. After his return to the United States of America in 1810, although he was now the possessor of rich domains and a married man, Audubon spent his time observing birds and painting them. He explored America from New York to Fort Union and from Florida to Labrador, leaving little time for his business and mining interests. He devised a plan for collecting his numerous drawings and paintings together in a large work devoted to the birds of America. Having lost 200 engravings at Philadelphia spoilt by rats, he made good this damage and set off for England, where he had his collection published. *The Birds of America* is considered by some to be the finest work of natural history. The first volume, with 100 plates, appeared in 1830. The work was not to be completed until 1839. It then contained more than 1000 pictures. The reader may well be surprised that this book does not have a single plate from *The Birds of America*. This work has been so much plundered and its pictures reproduced in such abundance that it no longer has anything new to offer. We preferred to use several pictures taken from *Quadrupeds of North America*, which are little known and rarely reproduced. Helped by his two sons, Audubon not only drew the mammals of North America but observed them with great care. His 'biographies', to use his own expression, contain a wealth of information on the habits of the animals represented and are written in an elegant, precise style.

Birds and insects have been the favourite subjects of illustrators of animals, which explains why they have such a predominant place in this volume. Birds were the subject matter of the greatest illustrated texts of the nineteenth century, the work of John Gould (1804–1881), who dealt with the birds of Europe, the Himalayas and Australia. The texts themselves are lacking in distinction, but the plates are brilliant. Gould's paintings have everything: accuracy, beauty of colour and of posture. Gould was considerably helped by his wife, who was herself an excellent painter.

Besides these great illustrators there are others less well known who nevertheless possess both good taste and ability. Jacques Barraband (1768–1809) was the favourite painter of the travelling naturalist François Levaillant (1753–1825). He used all his artistic skill in the superb plates which accompany the text of the *Histoire naturelle des Oiseaux de Paradis*. Jean-Gabriel Prêtre, about whose life we know nothing, except that he was the illustrator of three books

by René-Primevère Lesson (another travelling naturalist) about birds of paradise, hummingbirds and colibris (1832–1835), was an excellent draughtsman, and his miniatures are beautiful. If there is another painter of animals who deserves to be rescued from obscurity it is Pauline de Courcelles, who subsequently became Madame Knip. She illustrated with matchless skill several large volumes on natural history. Every ornithologist knows *Les Colombes* (Paris, 1838), the text of which was compiled by a certain Florent Prévost and by her, too, it appears. Her plates are the most important part of this book.

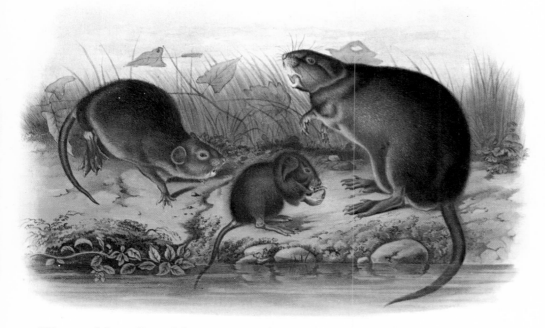

We could easily add to this list but we are not writing a treatise on illustrated natural history books. This task has, in any case, already been undertaken by scholarly book-lovers. We have tried to show that from the seventeenth century to around 1850 there had evolved a genuine art form, allied to an exact science. It was about this time that copperplate engraving was superseded first by lithography (Gould's plates are lithographs), then by sundry mechanical processes and finally by photography in various forms.

The natural history book has changed its appearance and its readership has grown. Its illustration content, composed of photographs, has gained in both precision and variety. An increasing number of people who are interested in nature buy and understand these books. It is to this public, to these friends, that we dedicate this volume – the quintessence of classical natural history and the pictorial evidence of an art which has disappeared.

Pierre-Paul Grassé

This lithograph, showing a family of muskrats (*Ondatra zibethica*) is typical of the style of John James Audubon. The animals, although depicted in typical stances and environments, are sometimes lacking in naturalness. The muskrats, which dig their burrows in the banks of watercourses and dykes, also build lodges of twigs and reeds cemented with mud, above a tree stump or a tuft of vegetation. The chamber of the lodge is linked to the outside by subterranean tunnels opening below the water level. Originating in North America, the muskrat has reached Europe, where its numbers are increasing to danger level, especially in the northern regions, causing the sides of rivers to collapse and embankments to cave in. Lithograph from *Quadrupeds of North America* (1849), by John James Audubon and the Reverend John Bachman.

Wild Boar
(Sus scrofa)

The domestic pig is derived from the Wild Boar, whose main characteristics it still retains. Feral pigs rapidly resume the outward appearance of their ancestor. It is by means of selection that breeders have created animals which, in appearance, are far removed from those members of the family which have remained in the wild state.

The Indian Sow, painted by Wailly, needs explanation. As always happens when a species is widespread there are variations in colour, size and other features, leading to the division into several subspecies. In the past, these subspecies have often been treated as species. One of these was called the Indian Wild Boar (*Sus cristatus*) or Crested Pig, because of its large erect ears and rather short snout.

The European domestic pig was of the long-legged, long-snouted breed until about 200 years ago when Chinese house pigs were crossed with the European to give the thick-set Berkshire. Indian breeds were also imported for further crosses to produce a higher meat yield.

Parchment in the French National Museum of Natural History painted from life by Paul-Louis de Wailly in 1810. Vol. 72, no. 67.

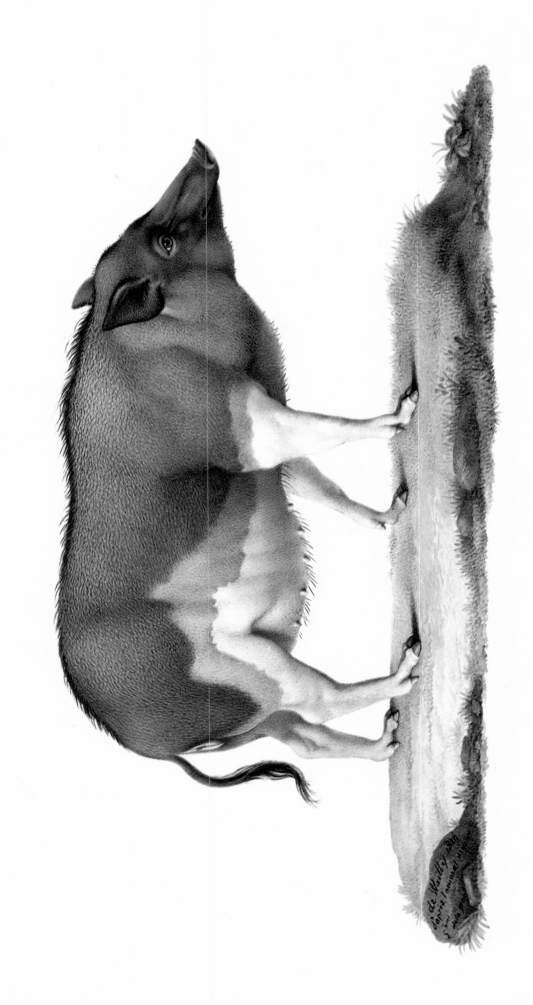

Alpaca
(Lama pacos)

A member of the camel family (Camelidae), the Alpaca was domesticated by the Peruvian Indians, at least as far back as 200 BC, before the Incas established their hegemony over the north-west part of South America.

According to some biologists, the Alpaca resulted from the crossing of the wild Vicuña (*Lama vicugna*) with the domesticated Llama (*Lama glama*) and there is every reason to believe that this hybrid produced a long-haired mutation, analogous to that of the Merino sheep. This opinion is not shared by everybody, however, and some authorities claim that the Alpaca, like the Llama, had as its sole ancestor the Guanaco (*Lama guanicoe*), which lives in the wild state in the Andes.

The Alpaca provides the finest, longest and silkiest wool produced by any animal and also gives an abundance of good-quality meat. It, therefore, constitutes a valuable resource for the impoverished peoples who live on the slopes of the cordilleras and high plateaus of Peru and Bolivia. The Alpaca thrives best at altitudes between 4000–5000 metres (13000–16000 feet). At lower altitudes it tends to develop rickets. Although it prefers air of low humidity its feet are sensitive to dry ground, which is said to produce a fatal foot disorder, and, therefore, it does best on damp ground with many pools. The mares foal in the rainy season, after a gestation period of eleven months. Also, the Alpaca is sheared, every two years, in the rainy season, which is in November or December, when temperatures are more or less uniform.

Parchment in the French National Museum of Natural History painted by Jean-Charles Werner in 1848. Vol. 102, no. 46.

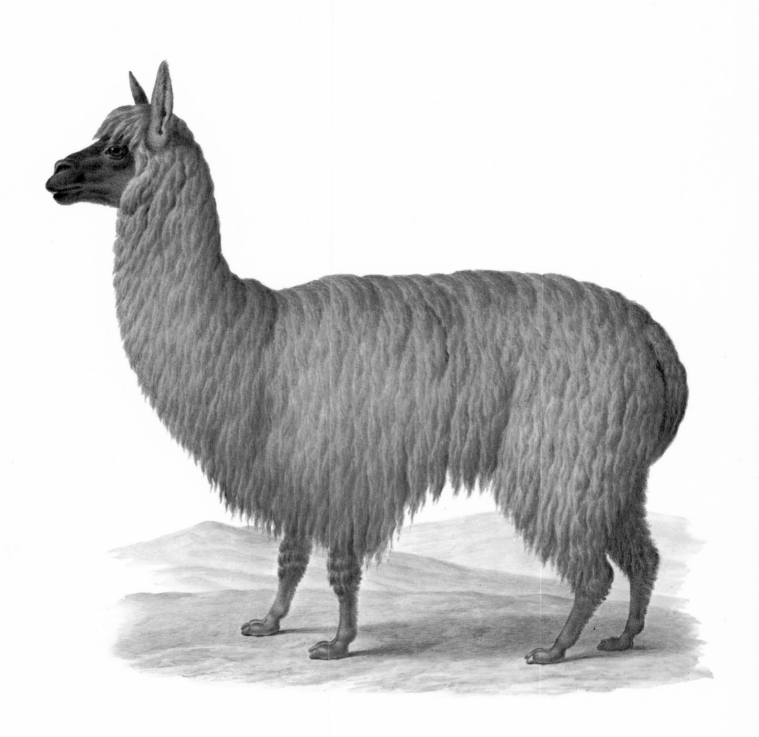

Zebu
(Bos indicus)

There is a divergence of opinion about the origin of the Zebu or Brahman Cattle. Some authorities have suggested it could be a hybrid between a member of the genus *Bibos* and the Wild Ox or Aurochs (*Bos primigenius*, almost certainly the ancestor of the western domestic cattle, *Bos taurus*), but this interbreeding, which is currently practised in Assam, produces individuals which bear scarcely any resemblance to the Zebu.

Other authorities are of the opinion that the Zebu, which is quite distinct from western domestic cattle and even more so from the Aurochs, originated in Asia where its ancestor was *Bos nomadicus* which lived in India at the beginning of the Quaternary period. The skeletons of each show striking similarities. The most ancient bones have been unearthed in a stratum in northern Mesopotamia and apparently date from around 4500 BC. This find does not invalidate the Indian origin of the Zebu.

The Zebu, which probably originated in India, has been taken north to China and east and south to much of Africa, including Madagascar. It has shown itself more robust and more resistant to certain infectious diseases as well as to hot, humid climates than western cattle, and its meat is just as good. Its milk yield does not match that of cows of European origin, but it has not been selectively bred for milk production.

Parchment in the French National
Museum of Natural History painted by
Nicolas Maréchal. Vol. 73, no. 75.

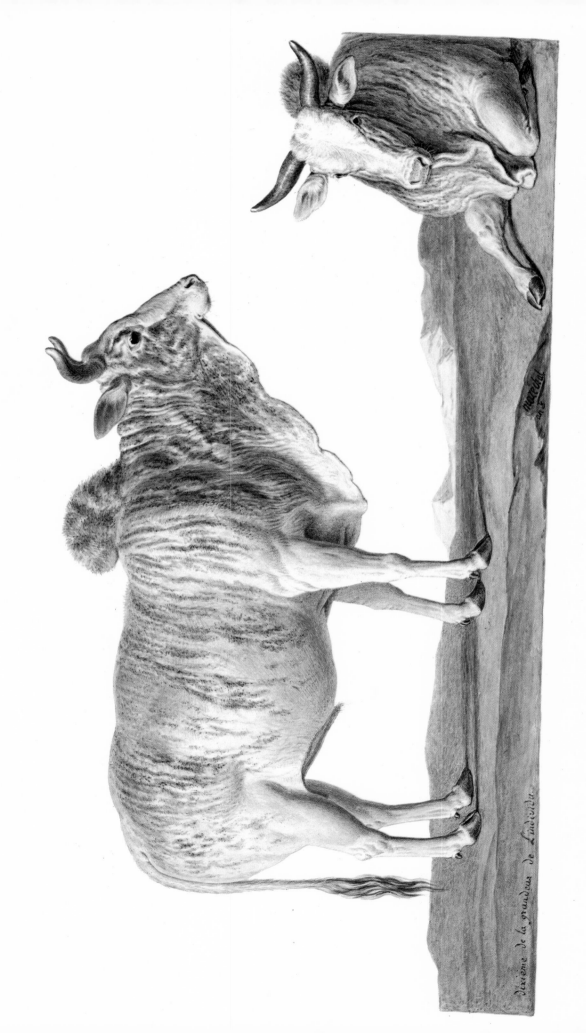

Sixième de la grandeur de l'individu.

Quagga Zebra

(Equus quagga)

The Quagga was one of the smallest of the zebras and the one which most closely resembled the horse. Its stripes scarcely extended beyond its forequarters, its hindquarters being all one colour. This animal was exterminated almost a century ago by human predation. The Boers, who killed it for its meat and hide, found what seemed to be an inexhaustible population of Quaggas. It would no doubt have appeared unbelievable to them that it could ever be wiped out, so they tended to kill with no thought for the future, as happened with the American Bison, or Buffalo, except that this was not entirely eclipsed.

The Quagga was the southernmost of the zebras, living on the high plateaus of southern Africa, south of the Orange River and east of the Kai River.

The specimen portrayed on the parchment opposite lived in the Menagerie of the Botanical Gardens in Paris. It died there in 1793, the very year in which it was drawn by Maréchal. The last Quagga was an inmate of the Artis Zoo, in Amsterdam, where it died in 1883.

Parchment in the French National
Museum of Natural History painted by
Nicolas Maréchal in 1793. Vol. 72,
no. 93.

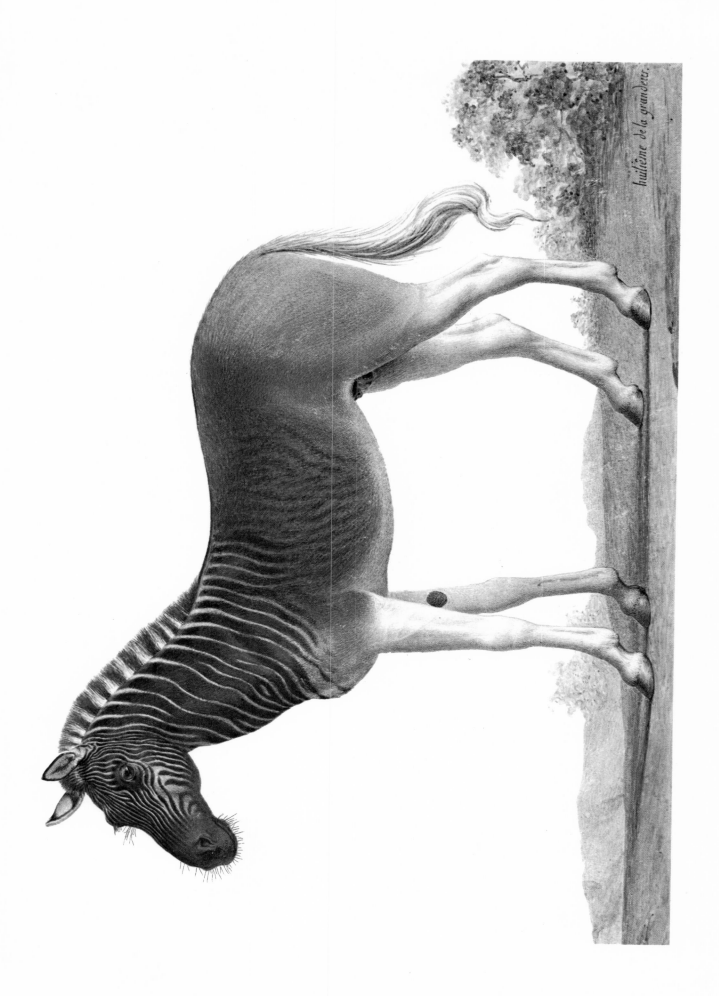

Eastern Flying Squirrel
(*Glaucomys volans*)

This little rodent is found in eastern United States and parts of Central America. It lives in forests at the tops of trees and is fairly gregarious. During the daytime the Eastern Flying Squirrels shun the light and sleep in the hollows of trees on a bed of leaves. They awaken at twilight and go off in search of their food which consists of seeds, fruit and buds.

They use the patagium or membrane, which connects the front and hind legs on each flank, as a sort of parachute. From a high branch they launch themselves into space and spread their 'sail', stretching their limbs wide apart. In one jump they can cover up to 45 metres (150 feet). In order to absorb the shock when landing, they bring their legs forward and grab at the branch they want to reach. They rarely come down to the ground except to gather up fallen fruit or seeds, which they store for the winter. This Squirrel is a prolific breeder, producing sometimes two, less commonly three litters a year, of two to six young in each litter.

In painting this very beautiful parchment Nicholas Huet allowed himself a considerable amount of artistic licence, for the charming scene which he depicts here owes more to the imagination than it does to reality.

Parchment in the French National
Museum of Natural History painted by
Nicolas Huet in 1806. Vol. 72, no. 4.

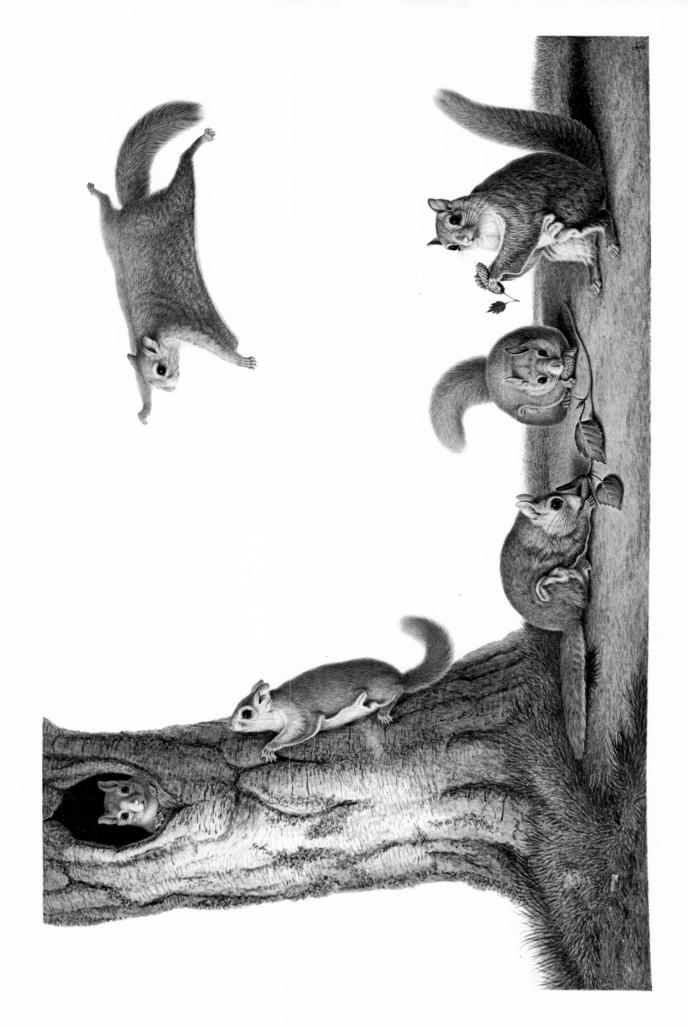

Tree hyrax
(Dendrohyrax)

The hyraxes are about the size of a rabbit but look like overgrown guinea pigs. However, they are not rodents but the nearest living relatives of elephants and rhinoceroses, as shown by the structure of their skeleton. Their most remarkable feature is their feet. The front feet have four functional toes and a vestigial first toe, with short nails, reminiscent of those of the rhinoceros. The hind feet have three toes. The inner toe of each hind foot has a curved claw and the other two have nails.

There are two kinds of hyrax. The best known is the rock hyrax (*Procavia*), also known as the dassie, rock rabbit or coney, which lives among rocks. The soles of its feet are hairy, giving it a grip on smooth rock surfaces, over which it clambers and runs with ease. The rock hyrax is found throughout most of Africa as well as in Syria and southern Arabia. The tree hyrax is found from Zaire to Kenya and southwards to South Africa. It is very like the rock hyrax in appearance but it lives in trees. The soles of its feet are naked, giving a grip on bark. Both kinds of hyrax are vegetarian.

Rock hyraxes live in colonies, spending much of the day basking in the sun and keeping an eye open for leopards, hawks and eagles, which prey on them. When alarmed they either utter a whistle or a chattering noise, and all their fellows within earshot make for their refuges among the rocks. The tree hyrax is also noted for its voice, which is much louder than that of the rock hyrax. It starts as a series of groans and ends in a screaming wail.

They always urinate and defecate in the same place and in the course of time their mingled excrement turns into a brown mass, the *hyraceum*, which was used in medicine in ancient times.

Parchment in the French National Museum of Natural History painted from nature by Nicolas Huet in September 1815. Vol. 72, no. 79.

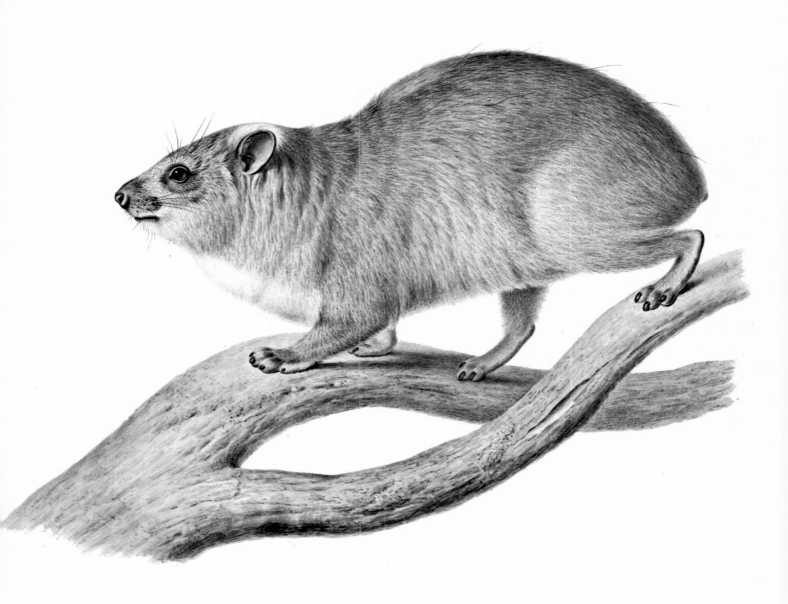

Short-eared Brush-tail Possum or Bobuck

(Trichosurus caninus)

The animal portrayed on this parchment is thought to be *Trichosurus caninus* due to its short, rounded ears and the shape of its tail.

The *Trichosurus*, which are marsupials inhabiting Australia and Tasmania, have a vague resemblance to the fox. Although they are prolific breeders and can adapt themselves to almost any environment, they are threatened, if not by extinction, at the very least by a severe decrease in their numbers by being ruthlessly hunted for their fine fur.

In forested regions they are tree dwellers, resting in hollows in trees, whereas in the treeless zones they seek refuge in rabbit burrows. During the daytime, they either sleep or remain otherwise motionless, becoming active at nightfall.

Their diet is a vegetarian one. They eat the leaves and the fruit of several species of eucalyptus and of many other trees and are particularly fond of Peppermint gum.

Parchment in the French National Museum of Natural History painted from life by Jean-Charles Werner in February 1847. Vol. 102, no. 86.

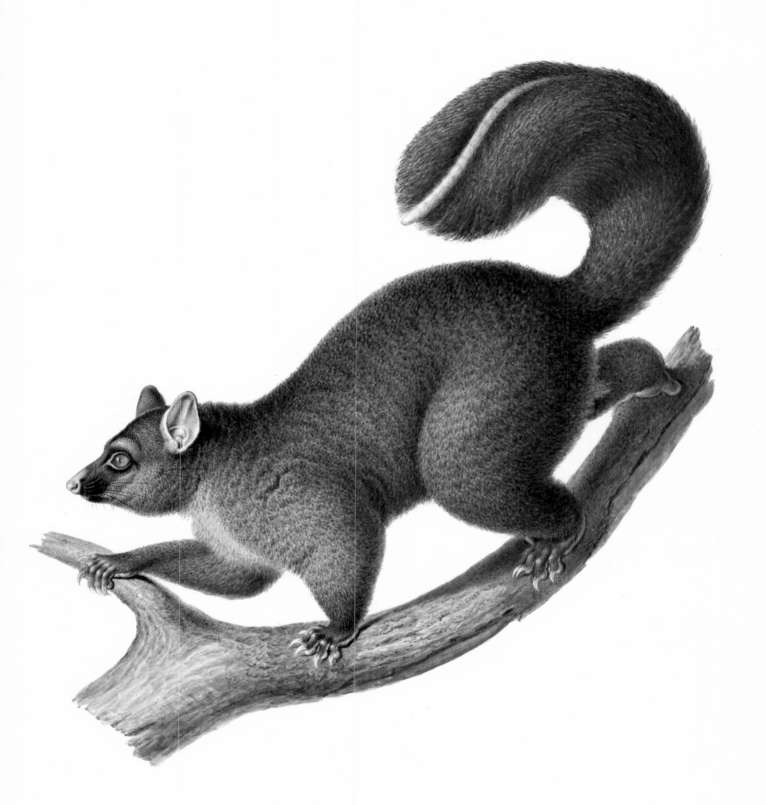

Dhole
(Cuon alpinus)

This member of the Canidae belongs to the small subfamily of the Simocyoninae, which is composed of three genera, and includes the African Wild Dog or Cape Hunting Dog (*Lycaon pictus*) and the Bush Dog (*Speothos venaticus*) of South America.

The Dholes or Indian Wild Dogs inhabit a vast region comprising a large part of central and east Asia, India and the East Indies.

They are very social, living in groups of five to twenty, sometimes forming packs of up to forty, which hunt down wild pigs, deer, antelopes and even the larger members of the cattle family. They are active in the daytime, but the preferred time for hunting is early morning. They must hunt over a large territory in order to avoid killing off all the game, to their own detriment, and hunting individuals keep in touch by using a whistling call. They also use howls, barks and whines, the latter especially when in distress.

As is usual in pack animals there is a hierarchy with dominant and subordinate members, often called the peck order, because this form of social ranking was first discovered in birds. The hierarchy is settled in the first place by fighting, but its consequence is peace within the pack, because once the ranking has been decided it is generally accepted.

Mating takes place in winter, the four to ten cubs being born two months later, in caves or holes dug in the ground. Members of the pack help guard a litter and also bring it food when the pups are weaned at five weeks old.

Parchment in the French National
Museum of Natural History painted by
Jean-Charles Werner in May 1850.
Vol. 102, no. 33.

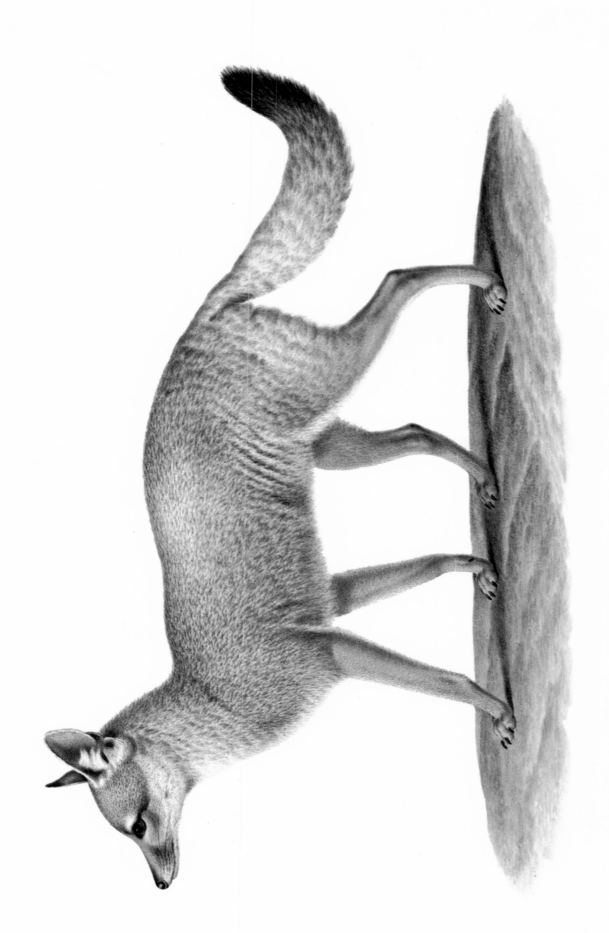

Giraffe
(*Giraffa camelopardalis*)

This beautiful miniature on parchment, in which Huet demonstrates the full range of his artistic skills, is also of some historical interest. The Giraffe portrayed is the one which was presented to Charles X of France in 1826 by the Khedive of Egypt and made a triumphant journey from Marseilles to Paris. The poor beast ended its days in 1845 in the Botanical Gardens in Paris, where Nicolas Huet was able to observe it at leisure. The first of its species to be introduced into Europe, it belonged to the reticulated variety.

During the Tertiary period the Giraffidae family was represented by many species in Africa, Europe and Asia, but the Giraffe and its relative the Okapi (*Okapia johnstoni*) are now all that remain of a large family. A thousand years ago Giraffes roamed south of the Orange River, in South Africa, as shown by drawings left by the Bushmen. They also inhabited what is now known as the Sahara desert, which was not so dry then as now.

The Giraffe is found only in Africa, either on plains where there are acacias or on savannas with scattered tree growth. It likes wide open country, the farthest reaches of which are clearly visible to its keen eyes.

It is very easy to kill with long-range weapons and would have been counted among the vanishing species if the protection accorded to it for some time now in parts of Africa had not saved it from extinction. It may be, however, that the Giraffe has only had a reprieve.

Parchment in the French National Museum of Natural History painted by Nicolas Huet in September 1827. Vol. 73, no. 38A.

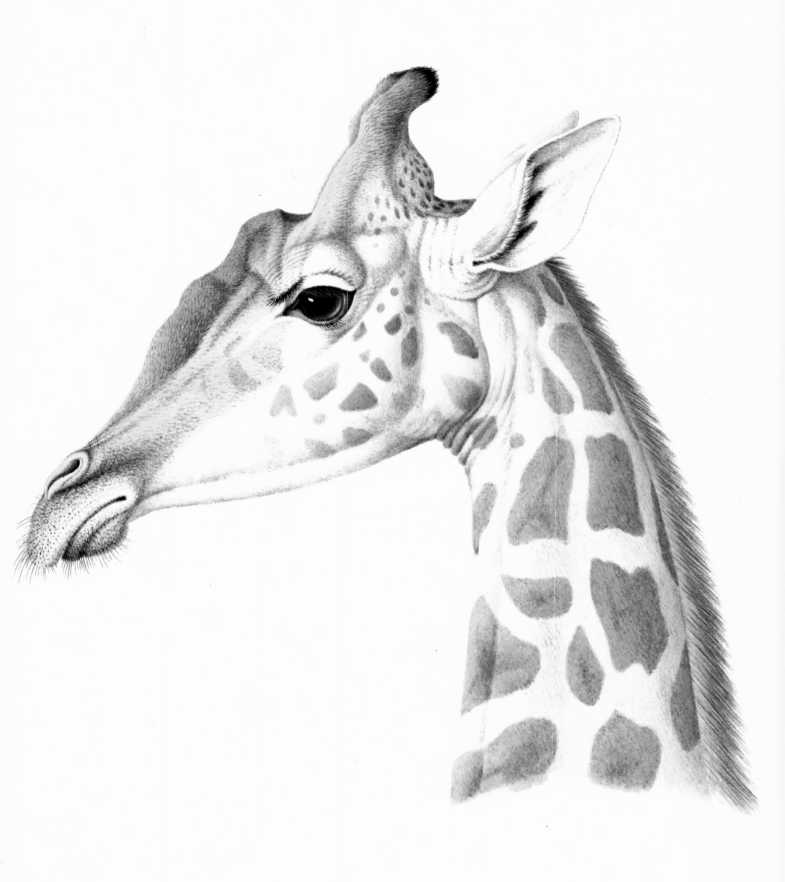

Common Wombat
(Vombatus ursinus)

This thickset marsupial inhabits the south-eastern part of Australia, being especially widespread in the low mountains of New South Wales. It frequents dry forests.

In its shape (with the exception of the tail) the Wombat resembles the Beaver. It feeds on grasses, roots (from which it removes the outer skin), bark and fungi, which it eats in the manner of rodents. Its upper and lower incisors, which are very powerful, are forward-sloping and form an acute angle to one another.

Using the powerful claws with which their stocky, muscular legs are equipped, they can quickly dig deep burrows up to a length of nearly 35 metres (115 feet).

Wombats lead a solitary existence and come together only for the purpose of mating. The female produces only one young a year, and this she carries for nearly six months in her marsupial pouch.

The ease with which they can be hunted is a serious threat to them. Dogs enter their burrows and throttle them or else force them out, whereupon they are shot by hunters. In many parts of Australia they have disappeared. The Common Wombat can very occasionally grow to a length of 1·2 metres (4 feet), and it weighs between 30–35 kilograms (66–77 pounds).

Parchment in the French National
Museum of Natural History painted by
Jean-Charles Werner in February 1847.
Vol. 102, no. 87.

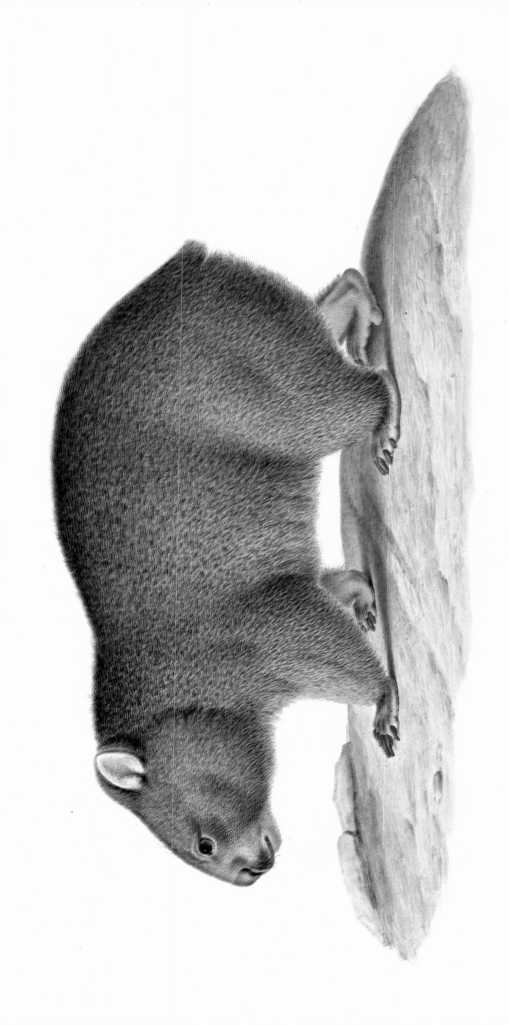

Common or Virginian Opossum

(Didelphis marsupialis virginiana)

The Virginian Opossum is probably the hardiest and most adaptable of the marsupials. It has an omnivorous diet and has no fear of the proximity of man, carrying its daring to the lengths of rummaging through the contents of litter bins.

This species differs very little from its ancestors, whose remains have been found in the gypsum of Montmartre, from which they were collected in 1805 and identified by Cuvier. (These fossils were classified as belonging to the genus *Peratherium*, closely related to *Didelphis*.)

Nowadays *Didelphis* is confined to America, where it is represented by several species. The Virginian Opossum, a subspecies of the Common Opossum, which measures, including its tail, up to 90 centimetres (35 inches) in length and weighs between 2–3 kilograms (4–6 pounds), occupies a region stretching from central Mexico to the latitude of New York.

Extremely prolific, the female produces about ten young in each litter and bears two litters a year. Less than two weeks after mating it gives birth to about twenty young, each less than 12 millimetres (0·5 inch) in length, and the only ones that survive are those that can seize hold of one of the thirteen teats in the marsupial pouch.

Parchment in the French National Museum of Natural History painted from life by Jean-Charles Werner in January 1847. Vol. 102, no. 90.

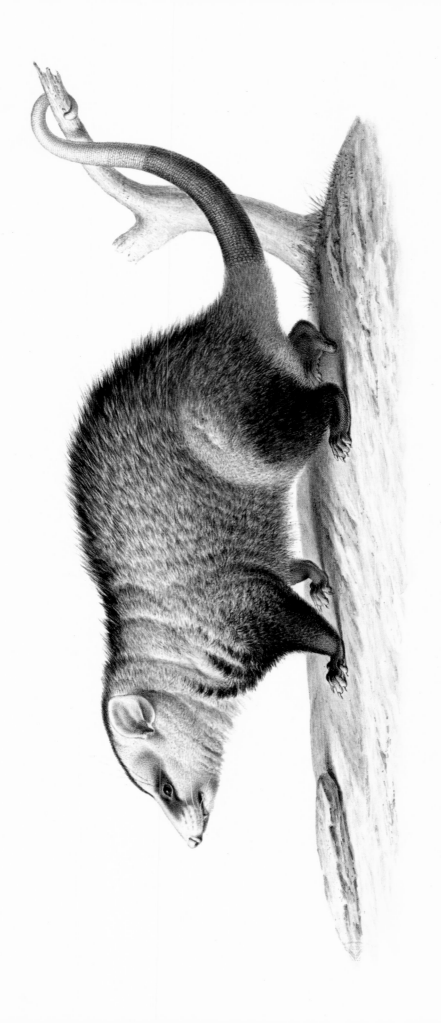

Common Hamster

(Cricetus cricetus)

Scarcely larger than the Brown Rat, the Hamster, with its squat little body and short legs, inhabits the plains of central Europe and Russia.

It digs different burrows according to the season. The one it inhabits in summer is neither deep nor very long and its only extension is a storehouse for provisions. The other, which is built for winter use at the end of the summer season, extends from 1–2 metres (3–6 feet) underground and comprises one or more chambers as living quarters and several storage places. During the summer the Hamster harvests the grain of cereals. An indefatigable and solitary gleaner, it can collect up to 10 kilograms (22 pounds) of corn in one burrow. When winter comes the Hamster falls into a lethargic state, a winter dormancy rather than hibernation, from which it arouses itself every five to seven days in order to urinate, defecate and eat.

During the breeding season the male abandons his dwelling and goes in search of a mate. When he comes across a territory occupied by a female he stops, and by secreting strong-smelling substances announces his presence and clearly indicates his ownership. He makes his way into the burrow in pursuit of the female, and mating takes place. The couple then separate and resume their solitary existence. The female has two litters a year, giving birth to from ten to sixteen young at each.

Parchment in the French National
Museum of Natural History painted
from life by Nicolas Huet in November
1818. Vol. 72, no. 16.

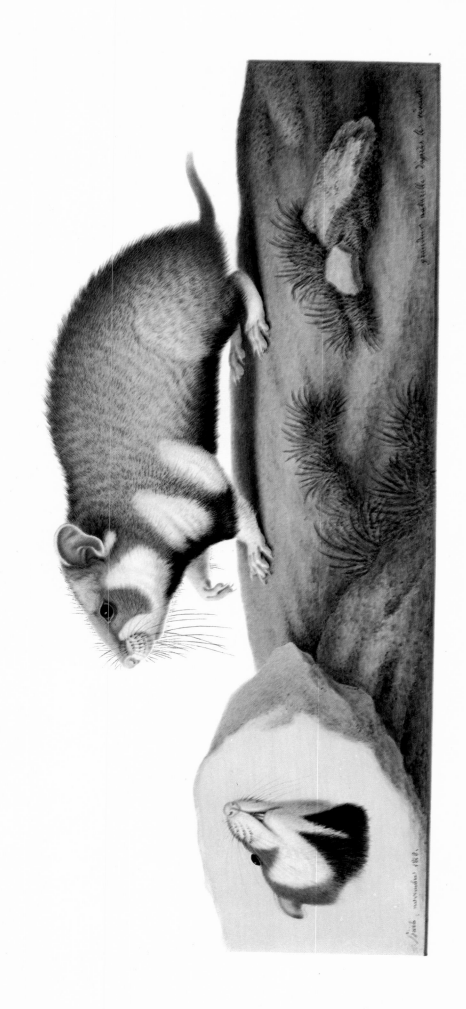

Algerian Gerbil

(*Gerbillus gerbillus*)

The gerbils or sand rats are rodents which inhabit the desert or subdesert regions from the Gobi in Asia to the Sahara. There are fifty species. *Gerbillus gerbillus* morpha *hirtipes* is peculiar to North Africa, from Morocco to Tunisia.

They all have silky fur, large ears, a very long tail, and long hind legs, which give them an extraordinary ability in jumping. Like other desert-living rodents, the gerbils have large tympanic vesicles.

They are most active at night, shunning the heat of the sun. They spend the daylight hours asleep in short, simple burrows, where the temperature is fairly constant and always much below that of the outside air. If exposed to the midday sun, they very soon die. They feed on seeds, leaves and insects.

The gerbils perform strange courtship displays, waltzing on the spot and pirouetting.

Many, probably all, gerbils are gregarious. They make their burrows so near to each other that the individuals inhabiting them may justifiably be referred to as forming colonies. This is not always obvious since the sand they live in is loose and as a consequence the mouths of the burrows are usually closed.

Parchment in the French National
Museum of Natural History painted by
Jean-Charles Werner in August 1851.
Vol. 102, no. 23.

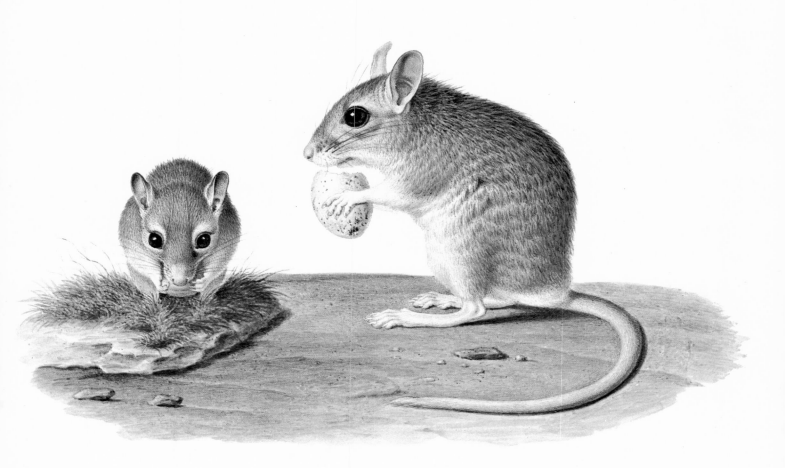

Hippopotamus
(Hippopotamus amphibius)

This parchment engraving presents an uncharacteristic picture of the Hippopotamus, but this is less surprising when one realizes that the subject portrayed is a young male aged about thirteen months. Its limbs are still fairly slender and the snout has not yet attained the coarse bulk which gives the Hippopotamus such a formidable appearance. The head and body length of a mature male may be as much as 4·6 metres (15 feet) and the weight up to 4·5 megagrams (tons).

The Hippopotamus or River Horse is a herbivore and emerges from the water each day in order to feed, always following the same paths to its pasturage. The skin of a Hippopotamus is glandular and secretes drops of moisture containing a red pigment, which has given rise to the statement that the animal sweats blood.

Since its flesh is plentiful and good to eat and it is easy to kill, many African peoples have hunted it down at every opportunity. It has disappeared altogether from many lakes and rivers and survives only in those regions where it receives strong protection. Large lakes with low banks covered in tall grasses are the chief places of refuge of the surviving bands.

From the Pliocene epoch until the Ice Ages the Hippopotamus inhabited Europe. Pygmy species were found in the islands of the Mediterranean, such as Crete and Cyprus.

Parchment in the French National Museum of Natural History painted by Jean-Charles Werner in September 1853. Vol. 102, no. 45.

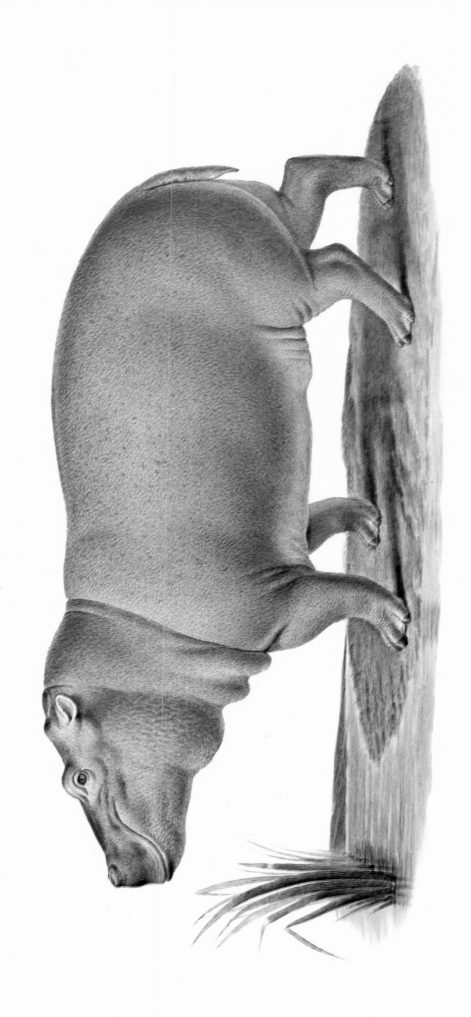

Common Eland

(*Taurotragus oryx*)

With an average height of 1·85 metres (6 feet) at the shoulder, and a weight of 700–1000 kilograms (0·75–1 ton), the Common Eland is the tallest of the antelopes, apart from the Giant Eland or Lord Derby's Eland (*Taurotragus derbianus*).

Of all the antelopes the Eland is probably the one with the most bovine features; its lines are heavy and solid and under its neck is a dewlap edged with long black hairs. It is recognizable by its horns which have two spiral twists near the base.

The Eland usually lives in small herds of twelve to thirty comprising one or two bulls, a few females and their young. During the rainy season, the herds sometimes join together, and nomadic bands of up to 200 individuals have been sighted. A few males lead a solitary existence. An Eland herd is continually on the move proceeding in single file at a fast walk, snatching food as it goes. During the dry season the animals dig up bulbs with their hoofs. They also seek out melons, for their high water content.

When alarmed they pause, then gallop away excitedly. They may even leap over each other's backs showing a surprising agility for so bulky an animal.

The Eland grazes on the savannas of Africa, from the Transvaal and Angola in the south, as far as Kilimanjaro and Kenya in the north. The female bears only one calf a year after a gestation period of 255–257 days. When mated with the bull of the Greater Kudu (*Strepsiceros strepsiceros*), this fine species has produced hybrids.

Parchment in the French National Museum of Natural History painted by Jean-Charles Werner in May 1846. Vol. 102, no. 58.

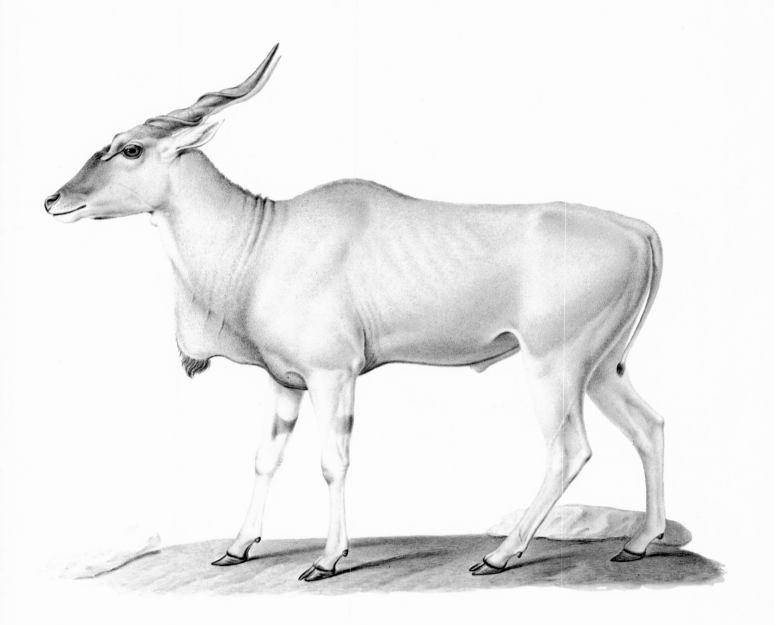

Two-toed Sloth
(Choloepus didactylus)

This magnificent parchment portrays a female Two-toed Sloth or Unau with its young. The animal has been painted in an unnatural position. As far as we know, the Unau never takes hold of fruit with its hands for the simple reason that it has no fingers. It pulls the fruit towards its mouth with its hooked claws. In fact, its main food is leaves, and it has a special fondness for a species which is characteristic of secondary forest, *Cecropia peltata*. The young Unau is shown in a typical position, clinging to its mother's abdomen with its arms outstretched.

The long, coarse hairs of this strange creature frequently have a greenish tinge, which is caused by unicellular green algae which grow in grooves in the hairs. The sloths (genera *Choloepus* and *Bradypus*) are exclusive to Central America and tropical South America. Besides the extreme slowness of their movements, they are incompletely warm-blooded, their body temperature fluctuating with changes in the air temperature. They are said to urinate and defecate only once every eight to fifteen days, which is a feature of other slow-moving animals. Except for the position, this portrait of an Unau is fairly accurate, even to the melancholy appearance of the snub-nosed face and the animal's air of nonchalance.

Parchment in the French National Museum of Natural History painted by Jean-Charles Werner in 1851. Vol. 102, no. 83.

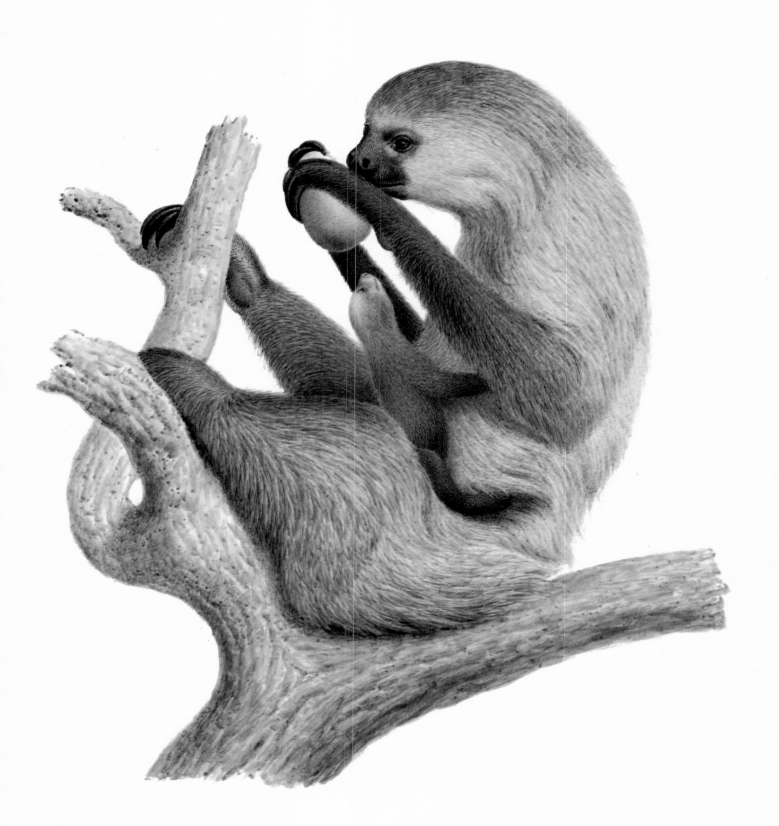

Swamp Deer stag

(Cervus (Rucervus) duvauceli)

The Swamp Deer stag is one of the finest of the Cervidae. It stands between 1–1·25 metres (3–4 feet) at the shoulder.

There is considerable variation in the pattern of the antlers. The brow tine projects forward forming an obtuse angle with the beam. At its upper end the beam may bear ten to fifteen points, sometimes more. Most of these project above the main beam. During the growth of the antlers, which are cast and re-grown each year, as is usual in the genus *Cervus*, they are covered with a beautiful red velvet.

During the rut the stag gives voice in a peculiar braying not unlike that of a donkey.

In the winter Swamp Deer become more gregarious and in former times herds several hundred strong could be seen, although the more usual size of a herd was thirty to fifty. The winter coat is a yellowish-brown with white underparts.

They are grazers and tend to avoid forests, keeping to the forest edges. They are less nocturnal than most deer and feed mainly in the middle of the day, from forenoon to early afternoon.

Parchment in the French National Museum of Natural History painted by Jean-Charles Werner in 1852. Vol. 102, no. 70.

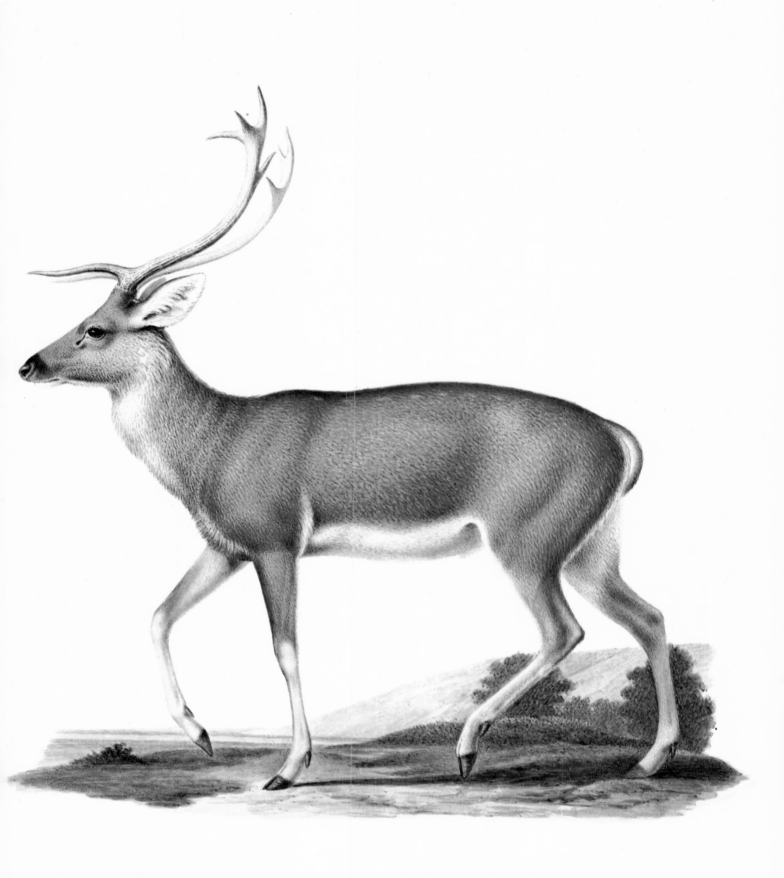

Swamp Deer hind
(Cervus (Rucervus) duvauceli)

The Swamp Deer lives in northern and eastern India, southern Nepal and Assam. It is also known as the Barasingha, a name sometimes given also to the Hangul or Kashmir Deer. In some parts of India the Swamp Deer is known as the Gond.

There are two subspecies, *Cervus duvauceli duvauceli*, in the area north of the Ganges, and *Cervus duvauceli branderi*, of the central regions of India. The former inhabits swamplands, the latter the grassy plains.

In the female of this member of the deer family (Cervidae) the slenderness of the limbs and the muzzle is more accentuated. On each side of the midline of the back the glossy coat is marked with a double line of light-coloured spots. The hind, shown here, is slighter in build than the Red Deer (*Cervus elaphus*) and, as in the Red Deer, it is slightly smaller than the stag.

During the rut, which takes place at the end of the year, the stag gathers a harem of hinds, much as happens with the Red Deer. The calves are spotted at first.

The Swamp Deer is numbered among the endangered species of deer, but it has been introduced to a few parks in various parts of the world, which should aid its conservation.

Parchment in the French National Museum of Natural History painted by Jean-Charles Werner in August–September 1852. Vol. 102, no. 71.

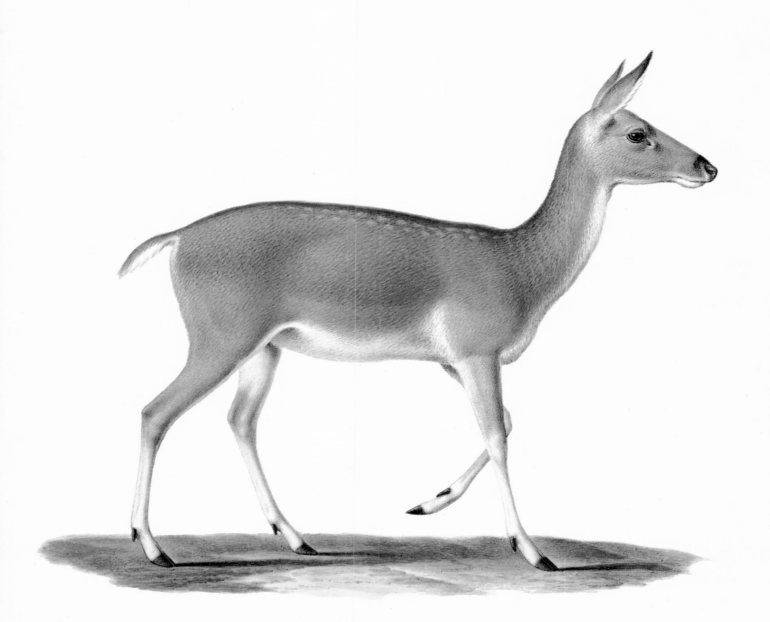

Gang-gang Cockatoo
(Callocephalon fimbriatum)

The early settlers in Australia found the Gang-gang abundant in the heavily wooded mountainous areas of extreme south-eastern Australia. Although it is also known as the Red-crowned or Red-headed Cockatoo, it is by general consent usually referred to by its aboriginal name. Today it is considerably more rare, owing largely to destruction of its habitat.

About 34 centimetres (13·5 inches) long, the bird is slate-grey with a greenish tinge on its front. Only the male has the red head with the untidy crest.

Gang-gangs are noisy birds and can be readily located by their calls which have the harsh rasping sounds of rusty hinges. These are often uttered in flight. They also make dog-like growls while feeding on the fruits of eucalyptus, acacia and other trees and shrubs.

These cockatoos are noted for the way a flock will rise above the tree-tops in aerial evolutions suddenly, returning as rapidly to the same tree. They also indulge in mutual preening in the tops of the trees, recalling the mutual grooming of monkeys.

The breeding season is from October to January. The birds nest in hollows in trees 16–28 metres (52–91 feet) above ground level, laying two white rounded eggs. Little more is known of the life history largely because of the height at which the nests are situated.

In winter it is not unusual for Gang-gangs to come into the streets in some towns in Victoria, to feed on the berries of trees planted there.

Watercolour on paper in the French
National Museum of Natural History
painted by Pancrace Bessa on 4
December 1827. Vol. 80, no. 90.

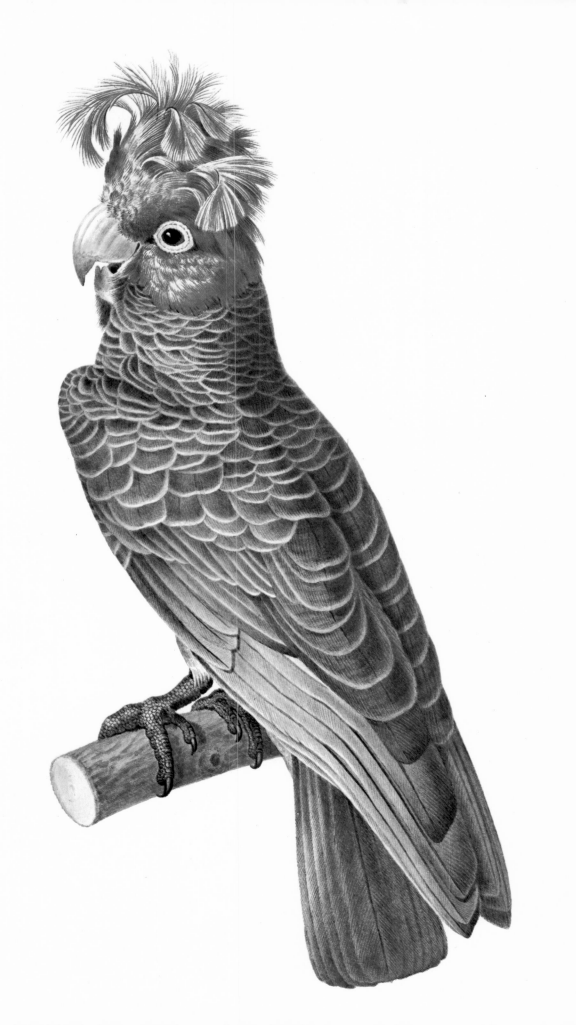

Ostrich
(Struthio camelus)

Today the Ostrich is found only in Africa from the Sahara southwards to East Africa and Zambia, where it inhabits open grasslands and savannas with scattered tree growth. The distribution of the Ostrich used to be much greater, however. Fossilized bones of the Ostrich have been found in several parts of the Ancient World including Greece, southern Russia and China. It inhabited the Sahara when this was not the desolate desert region it has become, but a place where man pitched his tents with his oxen alongside watercourses. Beads made from fragments of eggshells bear witness to the simultaneous presence of Ostrich and man.

The Ostrich eats almost anything and has a voracious appetite. However, its basic diet is vegetation, and it feeds mainly on plant foods, such as seeds, leaves, fruit and shoots. It also takes a variety of invertebrates, such as insects, as well as small lizards. Ostriches swallow grit and small pebbles, to aid digestion.

This huge running bird, which can attain a height of 2·5 metres (8 feet), lives in flocks of up to several dozen individuals. The female, which lays eggs until an advanced age (thirty-five years), produces up to forty-five eggs a year under domestication. The removal of the eggs stimulates further laying. The egg weighs between 1·2 and 1·5 kilograms (2·6–3·3 pounds), and the yolk is delicious.

Here the painter has represented a male Ostrich, which is recognizable by its black plumage with white feathers in its flightless wings and its tail. The female is grey-brown.

Parchment in the French National Museum of Natural History painted by Nicolas Maréchal in 1798. Vol. 82, no. 2.

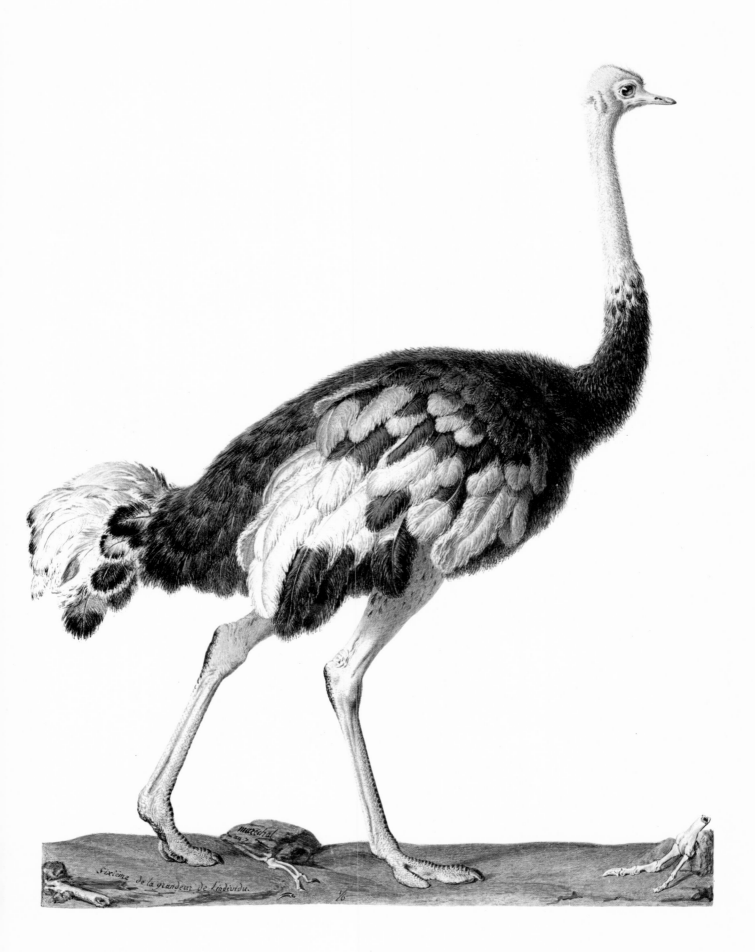

Sixième de la grandeur de l'individu.

Little Bittern
(Ixobrychus minutus)

The Little Bittern is the smallest of the European herons, with a maximum length of 35 centimetres (14 inches). It spends the summer in Europe where it breeds, although in the British Isles it is only an occasional and irregular visitor, usually between April and October.

It inhabits the edge of marshes, low banks covered with rushes and reeds deposited there by sluggish rivers, backwaters and even small ponds. It builds its nest in isolation, in remote, even inaccessible places, sometimes just above water level, occasionally in willows at heights of up to 3 metres (10 feet). Its diet consists of fish, molluscs and various small aquatic invertebrates. This timid, secretive bird which looks like a miniature Night Heron (*Nycticorax nycticorax*), flies close to the ground beating its wings very rapidly and hovering. It is active mainly at dusk.

At the approach of winter, grouped together in flocks of about fifteen individuals, the Little Bitterns leave Europe and make their way south spreading mainly over North Africa and also, but to a lesser degree, over tropical Africa.

Parchment in the French National
Museum of Natural History painted by
Nicolas Robert. Vol. 82, no. 62.

Woodcock
(Scolopax rusticola)

The Woodcock's plumage is cryptically coloured grey-brown and rufous, making a most effective camouflage against the leaf litter strewing the ground of the moist woodlands and coppices that form its habitat. It spends the day under cover and does not become active until dusk. When disturbed it may take flight making a distinctive rustling with its wings and without uttering a cry. Its flight is swift but erratic and silhouetted against the sky it appears to be without a neck. Its tail is short and the long straight beak is directed downwards.

Woodcock feed on earthworms and insects found by probing soft ground with the bill, which is sensitive at the tip, prey being located by touch.

A characteristic feature during the breeding season is the male's display flight, at dusk and dawn, when it patrols its territory. This is known as roding. The flight follows a set route and is accompanied by two special notes, one of which may be made by the wings.

The nest is on the ground, typically at the foot of a tree, where the female lays four cryptically coloured eggs. She alone incubates and rears the young. It has been proven, despite considerable scepticism, that she may carry her chicks in flight, one by one, held between the thighs, sometimes on the back.

The Woodcock ranges across Europe and northern Asia and reaches to North Africa and India in winter.

Parchment in the French National
Museum of Natural History painted by
Nicolas Robert. Vol. 83, no. 8.

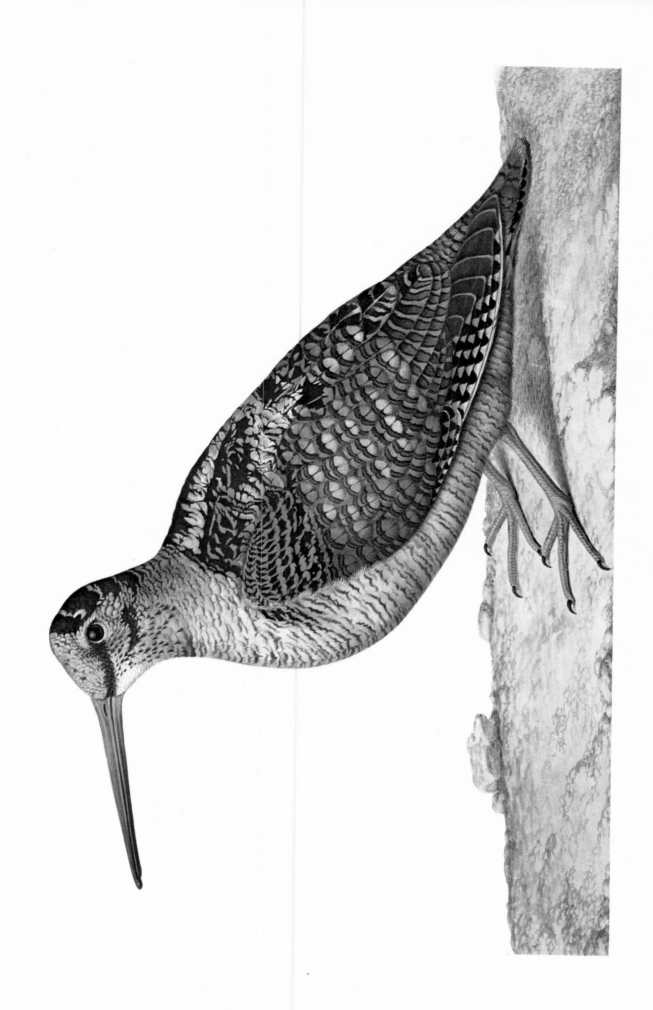

Andean Condor
(Vultur gryphus)

The Condor lives among the eternal snows, the inaccessible peaks and vast, silent, frozen wastes. No other bird, with the possible exception of the Pelican, has so excited the imagination of poets, and many South American states have adopted it as the emblem of liberty. Nevertheless, it is still slaughtered because it is believed to attack domestic stock occasionally, or else it is killed for its feathers. Although it is not an endangered species, it still needs protective legislation.

It is a New World vulture, one of the Cathartidae, which from the height of the clouds gazes down upon the herds of cattle or llamas, waiting for the stragglers, the sick or the injured to die before swooping down on the carcass. The Condor is a carrion-eater and not very well equipped for fighting, as the relative weakness of its talons reveals. The New World vultures are characterized by the absence of a septum separating the right nostril from the left one.

The Condor is one of the largest, if not the largest, bird of prey. It inhabits the entire length of Andean cordilleras from Venezuela to the Straits of Magellan.

The bird painted by Huet is a male, recognizable by the caruncles and coloured wattles on its face. The male is slightly larger than the female, with a wingspan that may reach 3 metres (10 feet), and a weight of up to 11 kilograms (24 pounds).

Parchment in the French National
Museum of Natural History painted by
Nicolas Huet in 1826. Vol. 77, no. 9.

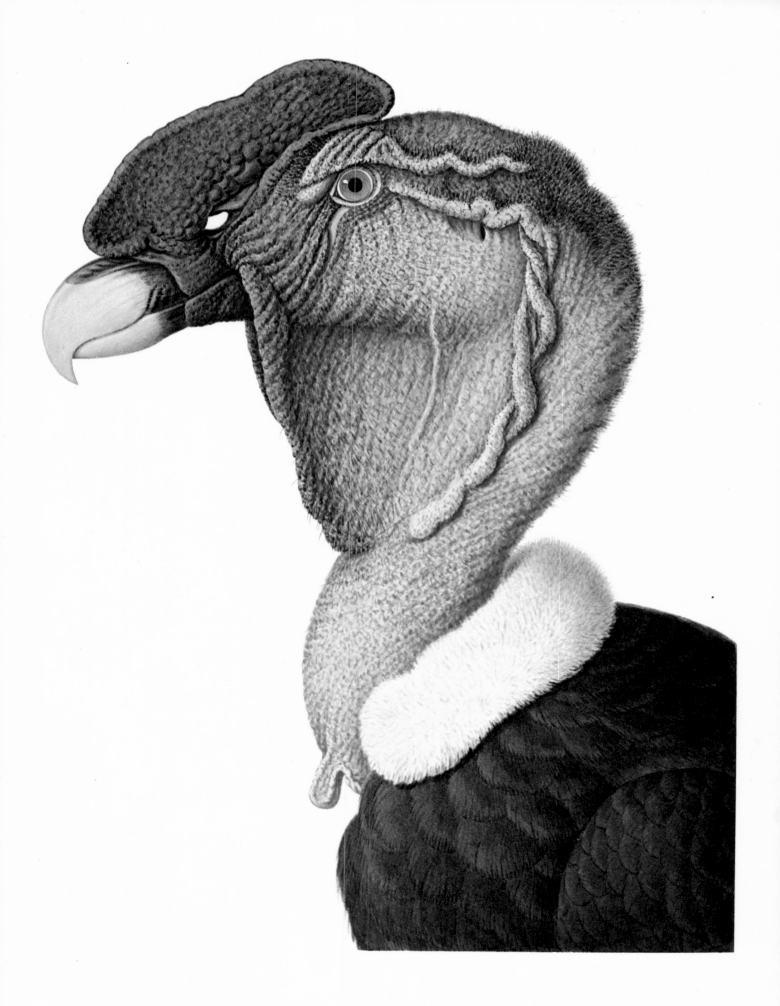

Greater Flamingo
(Phoenicopterus ruber roseus)

In Europe the Greater Flamingo is partly sedentary and nests in the delta of the Rhone (Camargue) and possibly in Andalusia in the marshes of the Guadalquivir. In North Africa, it breeds in the Tunisian saline lakes, and in Mauritania on the Arguin Bank and the Middle Dra. It also occurs in other parts of Africa, Asia and South America.

This bird has some strange habits. In order to eat it has to perform a strange manoeuvre – it plunges its head beneath the water of the mudflats and, using the extraordinary flexibility of its neck, turns its bill upside down. The lower mandible, which is now uppermost, moves up and down and the muddy water is sieved in such a manner that only tiny animals are retained and swallowed.

The nests of Flamingos are built of mud carried in the beak. They are shaped like truncated cones hollowed out at the top. The female lays one egg, rarely two, which she incubates in the usual manner by squatting on the nest with her long legs folded beneath her. Contrary to popular belief, she does not have her legs hanging down at the sides, and certainly not, as has been said, supporting herself on one leg. The young remain close to their nest for only a short time.

On occasions the Flamingos leave their territory suddenly and go on a long flight, but in general they return to the places where they are accustomed to nest.

Parchment in the French National Museum of Natural History painted by Nicolas Robert. Vol. 83, no. 62.

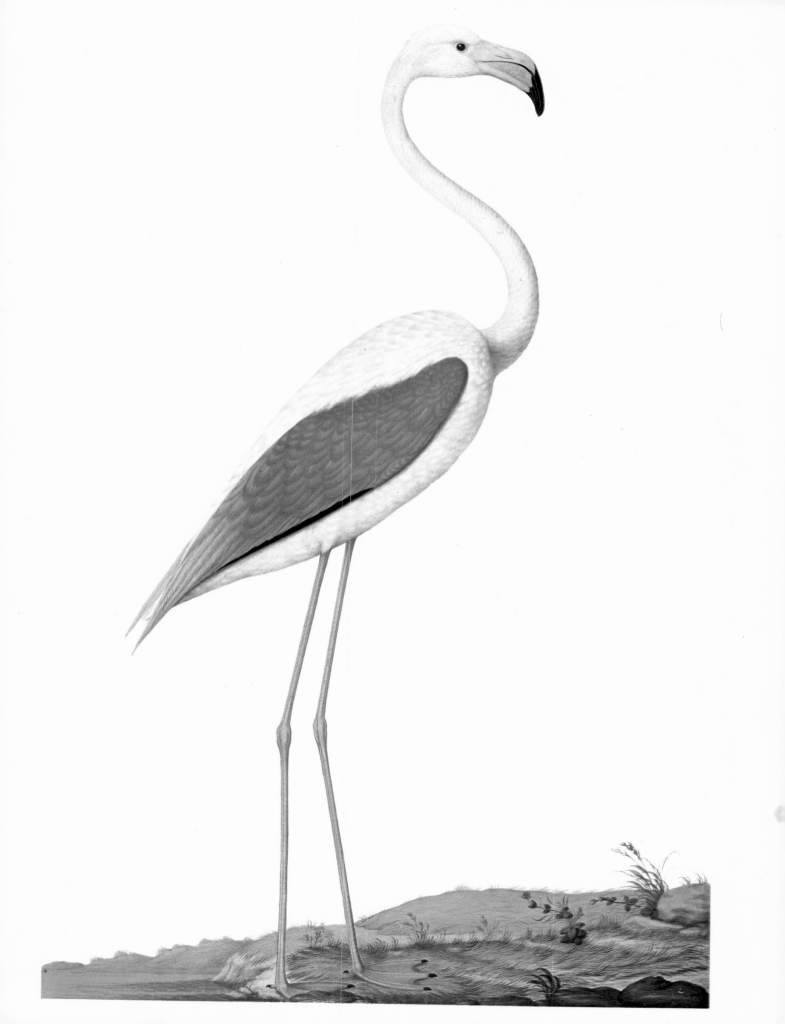

African Grey Parrot

(Psittacus erithacus)

The African Grey Parrot inhabits west Africa and feeds mainly on seeds and fruits. They are gregarious birds, and move about in noisy groups of from twenty to thirty individuals.

Its ability to mimic human speech has given rise to countless anecdotes. One of the best known is the story of the parrot belonging to Henry VIII of England, which, having fallen into the Thames, called the boatman to its rescue by imitating the voices of the passengers who hailed him from the shore.

Anyone who has kept an African Grey as a pet, under close observation for many years, will hesitate to discredit this story. To begin with, the best African Greys acquire an enormous vocabulary, including several hundred separate mechanical sounds, imitations of other birds' songs, snatches of human songs, separate words and sentences. They will, moreover, imitate certain mechanical sounds, not with the voice but by hitting or twanging the wires and other parts of their cages with the beak, deliberately trying these out until they have hit upon the correct match to the sound they have heard.

All this supports the view that the best African Greys are more accomplished mimics than any other species of bird, if only because they add 'instrumental music' to their vocal accomplishments. In addition, they can associate words or sentences appropriately with a particular person or situation, showing the kind of associations that a child up to two years of age, still working through the rudiments of speech, might use.

Parchment in the French National
Museum of Natural History painted by
Nicolas Robert. Vol. 80, no. 78.

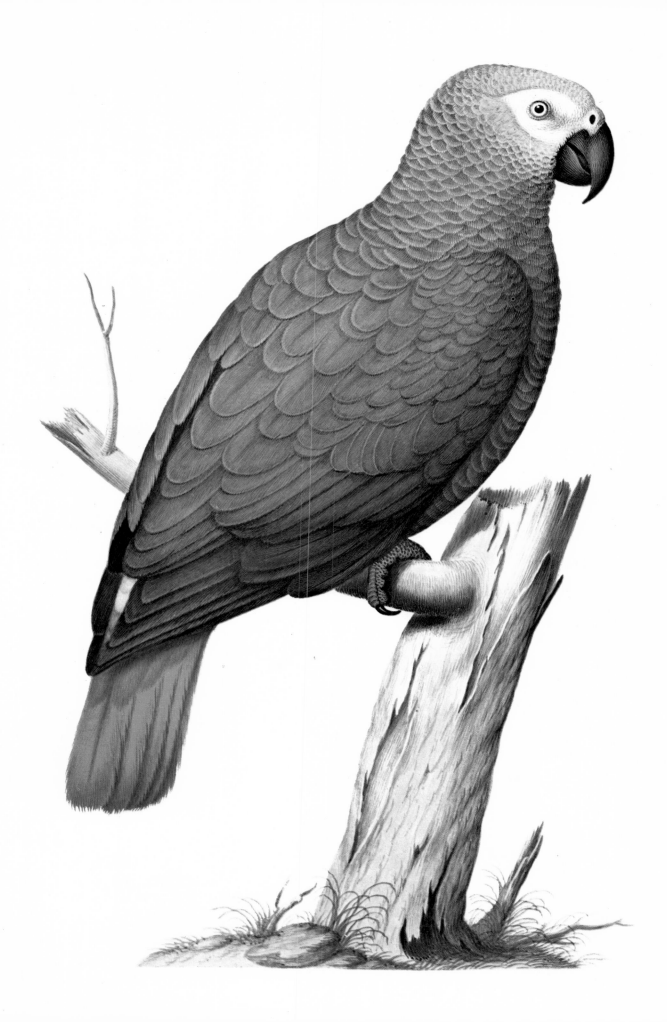

Orange-coloured Barbet

(Capito auratus)

The barbets, family Capitonidae, are tropical birds which belong to the order Piciformes. They owe their name to the long sensory bristles (modified feathers) which grow around the base of their bills and which form a sort of beard. They climb like woodpeckers or perch like bee-eaters. The Orange-coloured Barbet is the same size as a thrush. It belongs to the equatorial fauna of South America, and is quite common in Peru, where the local inhabitants call it 'Turu-Turu'. In the American genus *Capito* the bristles are less developed than in the Old World barbets. The female differs from the male in having black marks on the throat instead of it being uniformly orange in colour.

Barbets usually live in pairs, and utter powerful cries, which are repeated at length, and are among the most conspicuous noises in the areas in which they live. Some Asiatic barbets are known as brain-fever birds by those who have had to endure their persistent and monotonous calls. They continue to call throughout the heat of midday when other birds are silent. The metallic quality of their voices have earned some African and Asiatic barbets such names as blacksmith, coppersmith and tinkerbird.

Barbets rarely come down to the ground, for they are mainly tree-dwellers. They inhabit forests or wooded savannas, hollowing out their nests in the trunks of trees which have been attacked by insects or fungus and therefore offer little resistance. They feed on fruit and insects.

Parchment in the French National
Museum of Natural History painted by
de Wailly. Vol. 80, no. 54.

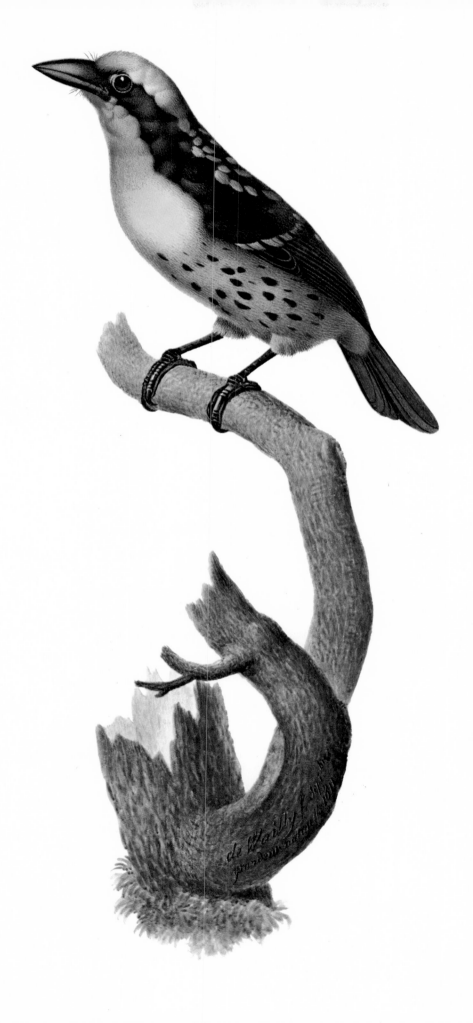

de Wailly
pardonnerai

Frilled Coquette Hummingbird

(Lophornis magnifica)

This very fine hummingbird frequents the forests and gardens of central and southern Brazil. It is the male (at the top of the miniature) which is most admired for its ornamental feathers and its iridescent colours.

As is the case with other hummingbirds, its metallic colours are due to the diffraction of light through the thin layers of the substance of which its feathers are made.

It feeds on nectar from the corollas of flowers, even tubular ones, which it sucks up while hovering in one spot. Small insects also enter into its diet to some extent.

Hummingbirds of the genus *Lophornis* are about 6 centimetres (2·5 inches) long, nearly the smallest in the family. Despite this small size they are most fearless and belligerent in defence of their feeding area.

The male Frilled Coquette Hummingbird has an interesting courtship display. He flies beneath the twig on which the female is perched, the noise of his wings reminiscent of a bee in a bottle. Backwards and forwards he flies, in half-circles, like the weight on a pendulum, drawing closer and closer to his mate. She, from time to time, makes short stabbing motions at him with her needle-sharp bill.

Parchment in the French National Museum of Natural History painted by Nicolas Huet in April 1817. Vol. 80, no. 24.

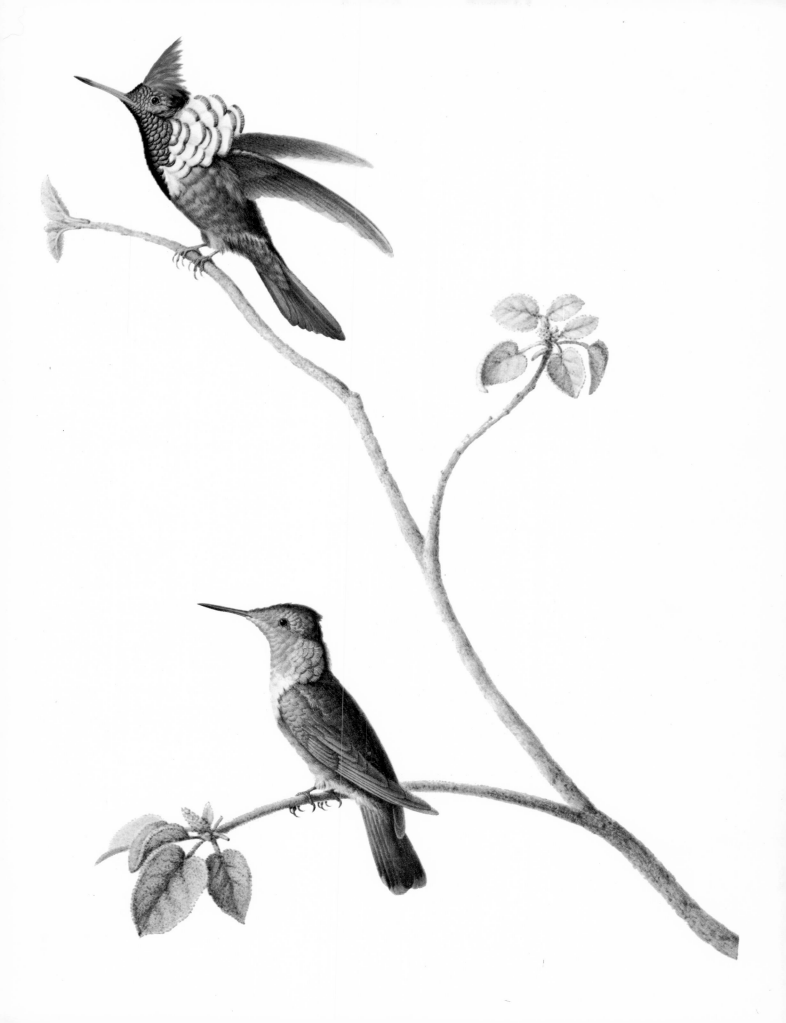

Grey Partridge
(Perdix perdix)

This game bird is a native resident of most of Europe and Central Asia. It has also been introduced into parts of North America.

The Grey Partridge remains attached to the place where it was born, many not moving more than a few hundred metres away, although the surplus of cocks move over a wider area in search of mates. It is entirely ground-living, never perching in trees, and prefers large cultivated fields, and copses and coverts, where it can find refuge.

It lives in coveys until the end of February or the beginning of March, when the groups begin to break up and mating pairs are formed. Gamekeepers claim that the couples remain united until death! Partridges mate during the first fine days of spring. The female builds a nest of straw and brushwood, in the cornfields, meadows or under bushes. Between twelve and twenty eggs, the size of pigeon's eggs, are laid at a time. Incubation lasts twenty-one days. The male does not sit on the eggs but remains by his mate whom he follows when she gets up to go and feed.

Young partridges run as soon as they are hatched, scratch about for food and follow their parents, who keep them together by calling to them unceasingly and leading them in the direction of suitable food. At first this is mainly small insects, such as the larvae of ants, and small earthworms. At the age of three weeks the chicks turn to a purely vegetarian diet of seeds and small leaves of flowering plants. The young of one hatching and the mother and father remain together and form a group.

Parchment in the French National
Museum of Natural History painted by
Nicolas Robert. Vol. 81, no. 72.

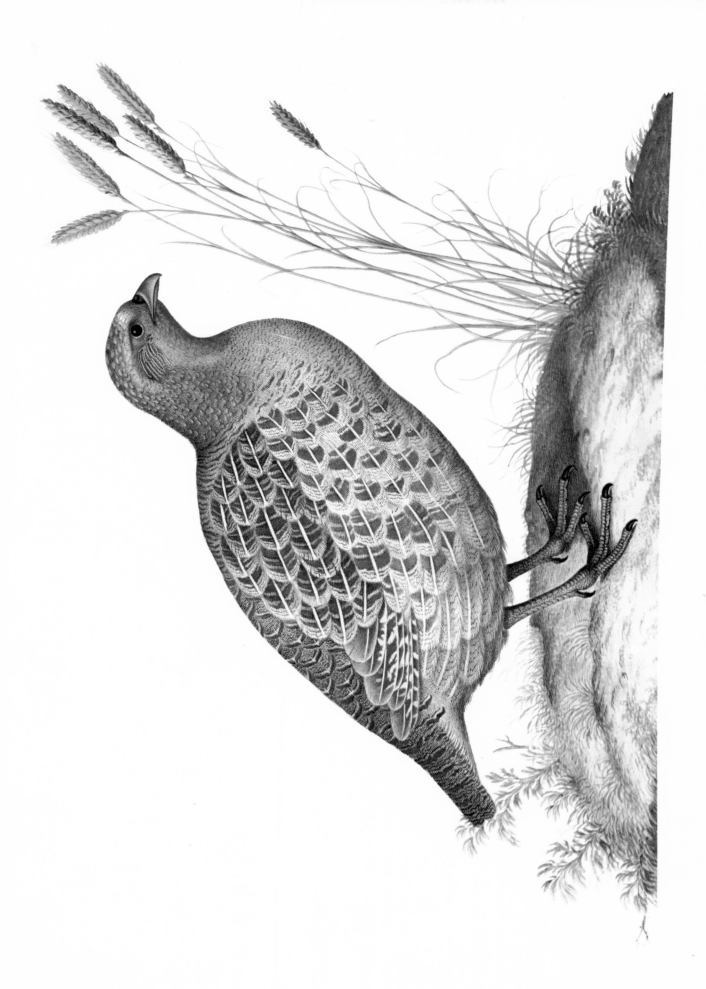

Lesser Bird of Paradise

(Paradisaea minor)

Like most other birds of paradise the Lesser Bird of Paradise is found only in New Guinea, where it is quite common. A denizen of large forests, it generally lives near the tops of trees.

It would be difficult, unless one had already been told, to identify the bird of paradise in this miniature, because it is a young male which has not yet acquired its ornamental plumage. When mature its head will be yellow, its throat emerald green. From each flank will spring a dense spray of plumes, yellow, red and orange, and from the tail two long 'wires'. The Lesser Bird of Paradise is similar to and only slightly smaller than the Greater Bird of Paradise (*Paradisaea apoda*). *Apoda* means legless, and the name was given because the legs had been cut off the first skins to reach Europe.

When Magellan returned from circumnavigating the world he brought two skins from the ruler of Batjan, one of the Molucca Islands. These had been entrusted to Magellan to present to the King of Spain. The Spanish courtiers, on seeing the skins, thought that such beauty was out of this world; therefore, they must come from paradise. The absence of legs and feet, cut off by the New Guinea traders before the skins were exported, to Batjan and other places, supported this idea. The birds must roost in the heavens, it was suggested, because they could never land on the ground. The story became elaborated: the birds not only lived on the wing, but were continually flying into the sun and the female was supposed to lay her eggs in a hole in the male's back.

Parchment in the French National
Museum of Natural History painted by
Paul-Louis de Wailly in August 1911.
Vol. 79, no. 106.

Pin-tailed Green Pigeon

(Treron apicauda)

The range of this pigeon is from the Himalayan foothills in western India to Assam and Burma. The male is about the size of the feral 'city pigeons', the female only slightly smaller and with less bright colours.

Pin-tailed Green Pigeons inhabit woodlands, especially evergreen hill forests, up to 2000 metres (6500 feet). They may, however, be found locally in wooded country in the plains when not breeding. They move about in pairs or in small parties, except when congregating at an abundant source of food; then they may be seen in much larger numbers. Their call is a musical whistling note.

Their food is fruit and berries, especially wild figs. When feeding, a Pin-tailed Green Pigeon climbs about the branches with something of the posture of a parakeet, with the head lowered and the tail close to the branch. It may hang head downwards to reach the fruit.

A characteristic habit is to sun itself on the top branches of a dead tree.

The nest is the usual fragile type typical of pigeons, in a tree or bush, 1·5–6 metres (5–20 feet) up from the ground. The usual two white eggs are laid and breeding occurs at most times of the year.

From a watercolour by Paul-Louis Oudart, taken from Charles-Louis Bonaparte's book: *Iconographie des Pigeons non figurés par Madame Knip (Mlle Pauline de Courcelles) dans les deux volumes de MM. Temminck et Florent Prévost.*

Black-tailed Godwit

(Limosa limosa)

The Black-tailed Godwit, a fine bird measuring about 40 centimetres (16 inches) in length, inhabits the northern and eastern regions of Europe. Its area of distribution covers much of Russia and eastern Europe and extends to Denmark, southern Sweden, Holland, Belgium, the north of France, Britain and the south-western coast of Iceland.

It lives near the water's edge, probing the mud and silt in search of insects, worms, molluscs and other invertebrates. In western Europe it is to be found only in autumn, for it is a bird of passage which can tolerate neither heat nor extreme cold. In winter it makes its way to the tidal lagoons, estuaries, great marshlands and beaches which become uncovered at low tide. Its plumage, which is reddish brown in summer, changes to grey in winter.

Pierre Belon, one of the first of the ornithologists, wrote: 'This is a bird which is very popular in France. It is unusual to find it a long way from the sea for it likes to feed in saltwater marshes. A great number of marsh birds are also night birds, and in fact this one in particular prefers to feed at night rather than in the daytime.'

Parchment in the French National
Museum of Natural History painted by
Nicolas Robert. Vol. 83, no. 11.

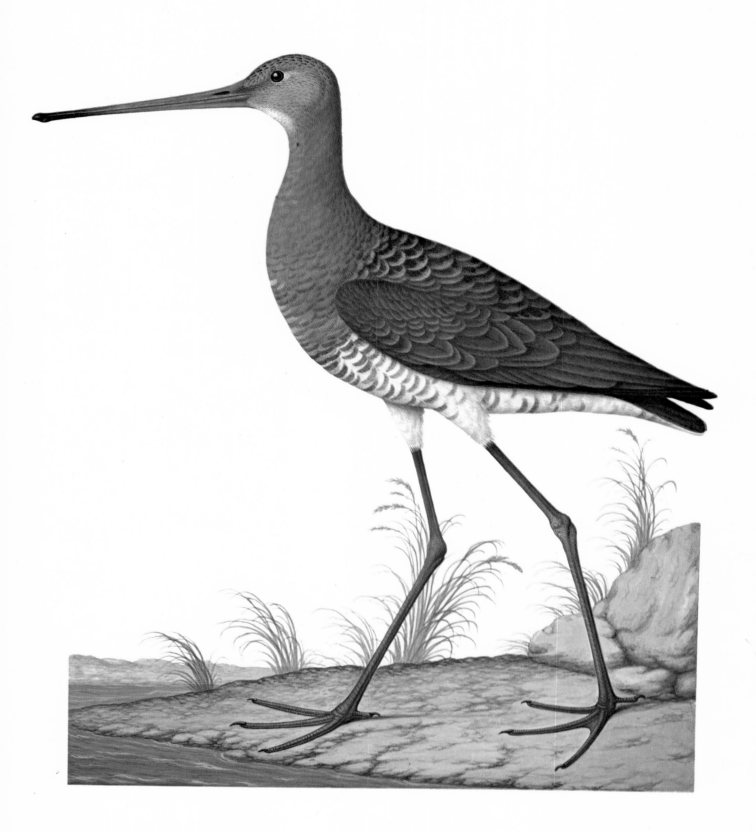

Pink-necked Green Pigeon

(Treron vernans)

This fine pigeon inhabits Asia from Burma through the Malay Archipelago to the Philippines. Its main source of food is fruit, and it is very fond of wild figs, which it gulps down without any difficulty. The seeds of the figs are ground up in the gizzard so are not voided. It lives on the outskirts of villages, taking advantage of the protection accorded to monkeys. Its flight is swift and powerful. The adult male measures about 27 centimetres (11 inches) in length.

The Pink-necked Green Pigeon belongs to what are known as the fruit pigeons and, more specifically, to the two dozen species of the genus *Treron*, most of which live in southern or south-eastern Asia, with a few in Africa. Their plumage is mainly a soft green with a yellowish or orange tinge and it lacks the iridescence of some of the larger, more showy fruit pigeons. Green pigeons are thickset, usually with a short tail.

Although a green pigeon may come to the ground such action is unusual. All green pigeons are highly arboreal. Even to drink they prefer to sidle down a branch hanging into water.

Coloured lithograph from a water-colour by Paul-Louis Oudart taken from the book by Charles-Louis Bonaparte: *Iconographie des Pigeons non figurés par Madame Knip (Mlle Pauline de Courcelles) dans les deux volumes de MM. Temminck et Florent Prévost*. Plate 13. Paris, 1857.

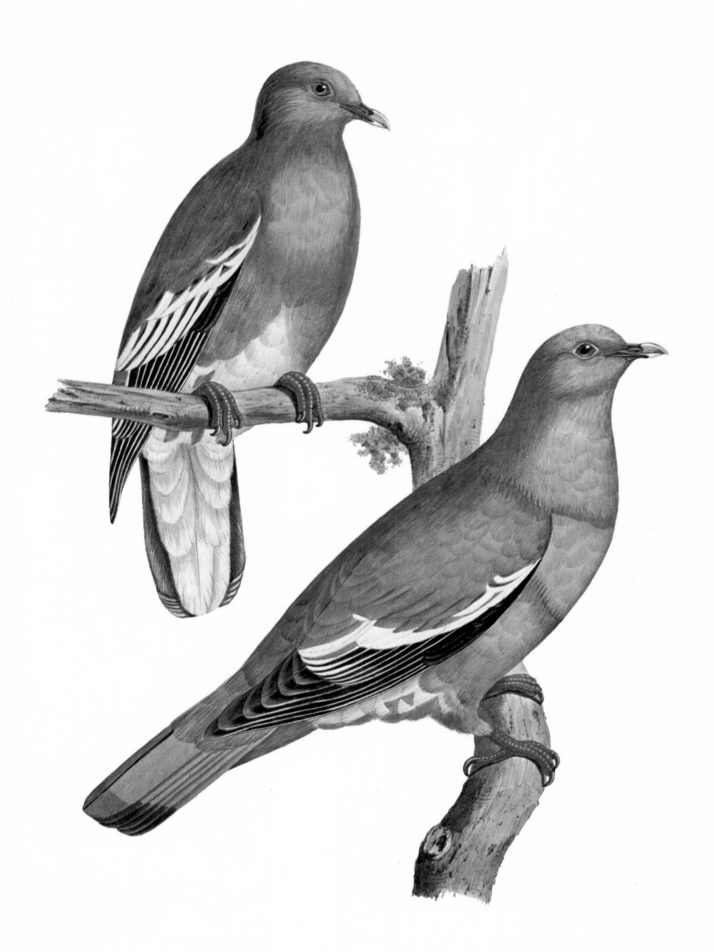

Great Crested Grebe

(Podiceps cristatus)

In spring this fine waterbird displays head and neck tufts which are greenish black in colour. Its cheeks are white and a red line runs from the beak to above the eye (sometimes stopping short). The upper part of the body is more or less darkish grey.

In autumn these grebes change their plumage, the upper part of the head, neck and trunk becoming darkish brown and the whole of the lower part of the body pure white. The crest becomes smaller, the ruff disappears and the beak, which was yellow and black, turns pink. The length of the bird does not exceed 50 centimetres (20 inches), the female being smaller than the male.

The Great Crested Grebes feed on molluscs, insects and fish. They have a strange habit of swallowing feathers, starting soon after they have been hatched. If they do not find any around them they do not hesitate to use their own. These feathers become lodged in the gizzard and are not digested. They stay there permanently in the form of a pellet whose function is not really known.

Grebes caw, scream and make crooning noises. Using reeds or rushes they build nests which float on stagnant waters near the banks and they attach them as best they can to plants. Before mating they perform a very elaborate courtship display. They are distributed throughout most of Europe and Asia, and parts of Africa, Australia and New Zealand.

Parchment in the French National
Museum of Natural History painted by
Nicolas Robert, Vol. 83, no. 72.

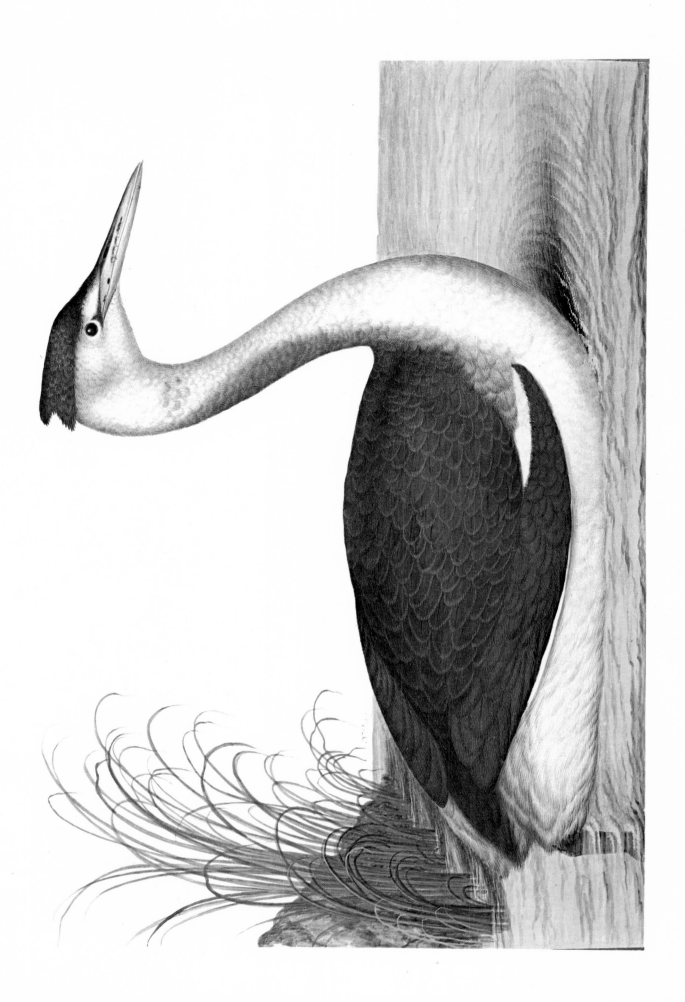

Great Hornbill

(Buceros bicornis)

This large bird, up to 150 centimetres (60 inches) in length, is found in western India and the Himalayan region, as well as much of south-east Asia as far as Sumatra. It is exclusively a tree-dweller and its diet consists mainly of fruit and berries to which are added insects, scorpions, lizards and snakes which are crushed before being swallowed. It flies with a series of wingbeats alternating with glides, but not in an undulating manner.

Great Hornbills fly over the forest in small groups uttering chuckles, bellows and roars. Their wings make a loud roaring noise because the flight feathers have no covering of secondary feathers.

The female lays her eggs in the hollow of a large tree and remains confined there during the whole of the incubation period. She blocks up the entrance with her own excreta, the male helping by plastering mud on the outside. This leaves only a tiny window through which the female receives the food brought by her mate. After the eggs are hatched, the female remains where she is and she and the chicks are fed by the male. During this time she moults and when the moult is complete she breaks out. The young are by this time almost ready to fly.

While incarcerated, the female, and later the chicks, contribute to nest sanitation by squirting their excreta accurately through the opening. A pair of hornbills probably mate for life and use the same nest cavity year after year. The number of years the nest cavity has been used can be gauged by the mound of excrement at the foot of the tree.

Watercolour taken from John Gould's work: *Century of Birds from the Himalaya Mountains*. London, 1832.

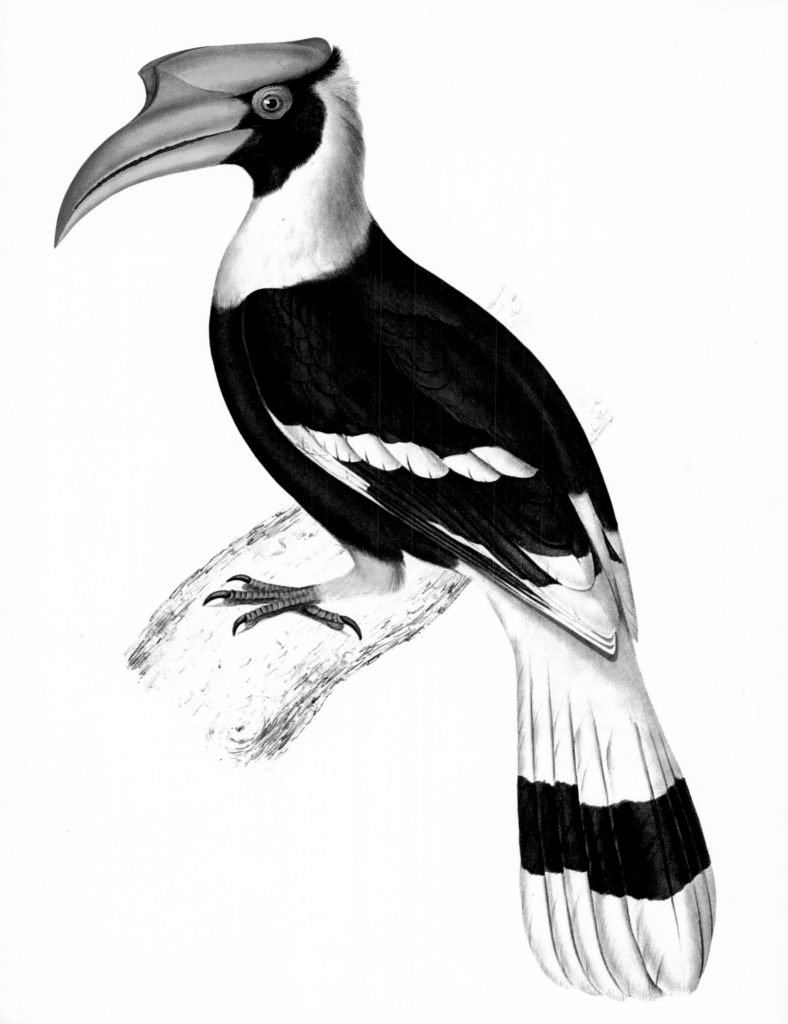

Reed Bunting
(Emberiza schoeniclus)

This small bird of the order Passeriformes, the male of which (shown above) has a somewhat different plumage from the female (below), is distributed throughout Europe. In its breeding plumage the male has a striking black head and neck, and a white collar.

The Reed Bunting prefers to live in marshy places with bushes or thickets growing alongside. It eats the seeds of reeds as shown in the painting.

In winter the Reed Bunting leaves the marshes and goes to look for its food in cultivated fields and in clearings in the woods. It builds its nest either on the ground or slightly above in the bushes.

In recent years in Britain, Reed Buntings have been increasingly recorded in drier habitats than those from which it gets its name. This may be due to the decrease in wetlands generally but it is also a tribute to the bird's adaptability. It has not only invaded agricultural land, even to breeding in fields of cereal crops, but has invaded gardens to feed at bird tables. Often it has been seen in company with flocks of sparrows in winter, from which it can be distinguished by its white outer tail feathers. It has also been seen in flocks of finches foraging over the stubble. Certain communities are migratory.

Parchment in the French National
Museum of Natural History painted by
Nicolas Robert. Vol. 79, no. 22.

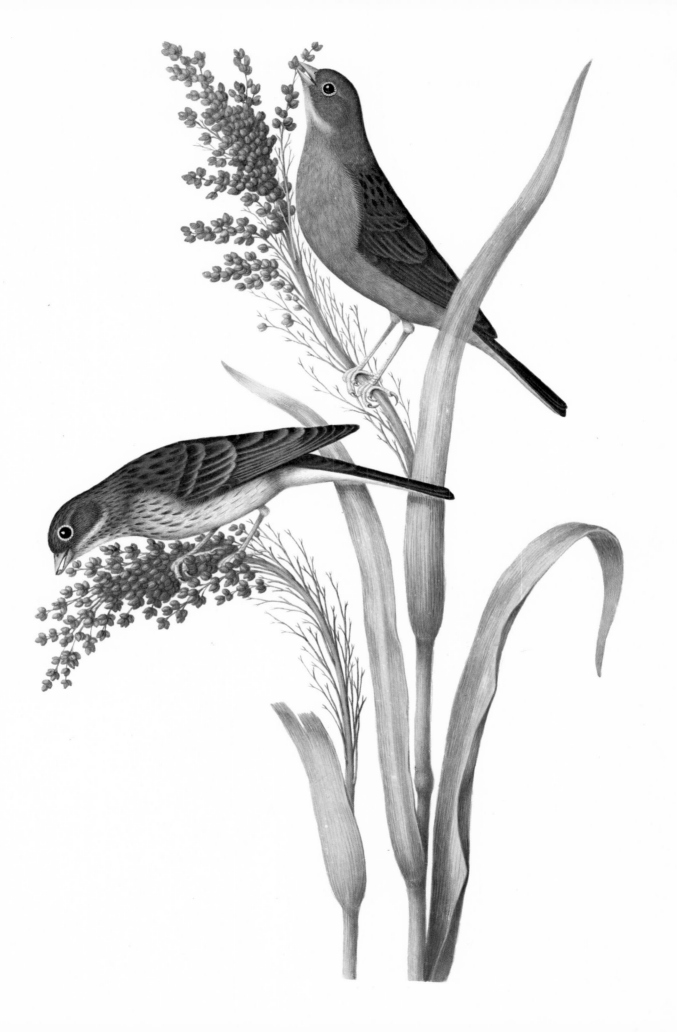

White Pelican

(Pelecanus onocrotalus)

This large bird with short legs and webbed feet lives near water, both fresh and salt. It carries a naked membranous pouch beneath the lower part of its enormous bill. The Pelican, so clumsy on land, flies with a wonderful freedom of movement, its wingspan being over 2·7 metres (9 feet). It is also a very good swimmer.

Pelicans hunt for fish, either singly, dropping down from a great height on to the water, or else in groups, swimming in a semi-circle, driving the fish towards the bank. In the shallow water the fish are then easily scooped up into the pouch.

The White Pelican builds large crude nests in trees or on the ground. It feeds its young with fish carried in its gullet, the baby thrusting its bill down the parent's throat to take it.

A native of northern and tropical Africa, the White Pelican does nevertheless form some colonies in Europe, in the Danube delta, and in parts of Asia, including the Aral Sea and Lake Balkhash.

The Pelican has been much used in heraldry, as a symbol of piety, especially by ecclesiastics. The legend goes that the mother will peck her own breast to feed her young with her blood. There seems to be no more foundation to this than the parents' habit, on the nest, of resting the pouched bill on the breast.

Parchment in the French National
Museum of Natural History painted by
Nicolas Robert. Vol. 84, no. 1.

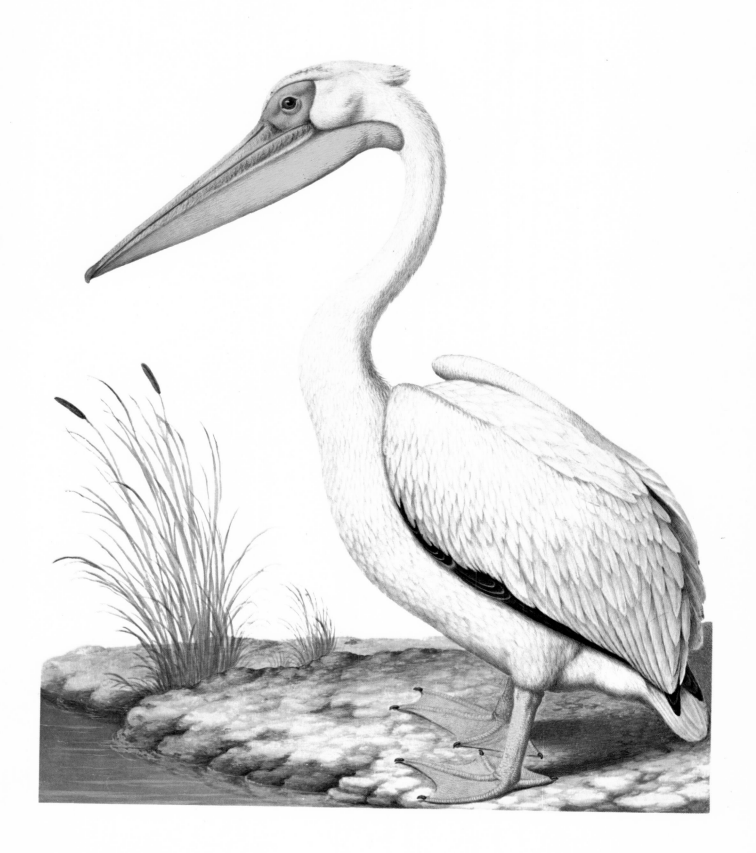

Little Ringed Plover

(Charadrius dubius)

Occasionally the miniaturists of the Museum painted specimens in various states of preservation, which made their identification difficult. For a long time there was doubt about the identification of the bird in this picture, not so much because of its state of preservation but because it is in fact an immature Little Ringed Plover. Some of the species of plover are difficult to recognize when presented in picture form, even when they are in adult plumage. When immature this difficulty is increased.

The picture proves, however, to be the young of the Little Ringed Plover which is a visitor from Africa to Europe in summer. It lives near fresh water especially where the river or lake has a pebbly bank, or where there is gravel or sand.

Its nest is a hole scratched out in the sand or shingle, or on dried mud or among grass, occasionally lined with plant stalks, fragments of shell or small stones. There are usually four eggs which are bluish green when laid but rapidly fade to a pale brownish buff, marked all over with small brown streaks and spots. Both parents share the incubation and tend the youngsters when they are hatched.

Parchment in the French National Museum of Natural History painted by Léon de Wailly, August 1823, Vol. 82, no. 25.

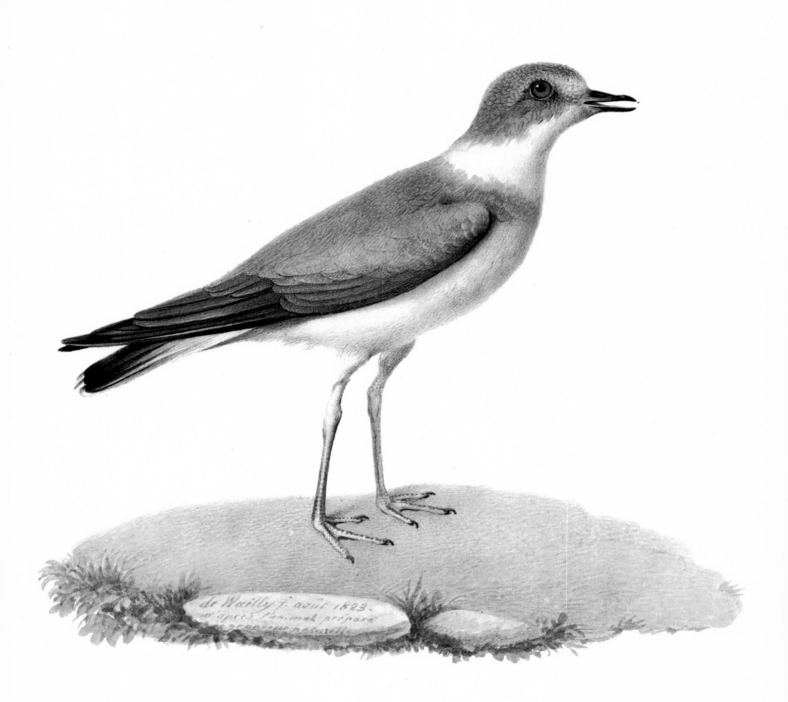

de Wailly f. août 1823.
d'après l'animal préparé
grandeur naturelle

Moustache Parakeet
(Psittacula alexandri fasciata)

The Moustache Parakeet or Banded Parakeet inhabits tropical Asia and is commonly found in India. The genus *Psittacula* is found in the tropics, in Africa as well as in Asia. Those species which were confined to islands, such as *Psittacula eques* on Réunion, have been completely exterminated by man.

All species of the genus *Psittacula* are similar in habits. They have somewhat the build of Budgerigars but are about twice the length. They move about in flocks of up to 100, feeding on fruits such as figs, on seeds, grain and flowers.

The plumage is typically apple green ornamented with soft colours. Black lines on the head, which tend to impart an aggressive expression, enable these parrots to distinguish between members of their own and other species. The aggressive expression is not wholly delusory, for these small elegant parrots have a belligerent temperament.

When moving about the flocks fly high over the trees in a swift noisy flight. As they settle in a tree they fall silent and all that can be heard is an occasional screech.

Psittacula species nest in holes in trees, either in natural holes in decaying wood or in cavities carved out by woodpeckers and barbets. Up to six pure-white eggs are laid but little is known about the breeding biology. This seems, from the few observations made, to have the basic pattern of parrots. In his courtship a male struts along a branch towards a female and feeds her by regurgitating food into her mouth.

Parchment in the French National Museum of Natural History painted from life by Nicolas Huet in 1819. Vol. 80, no. 85.

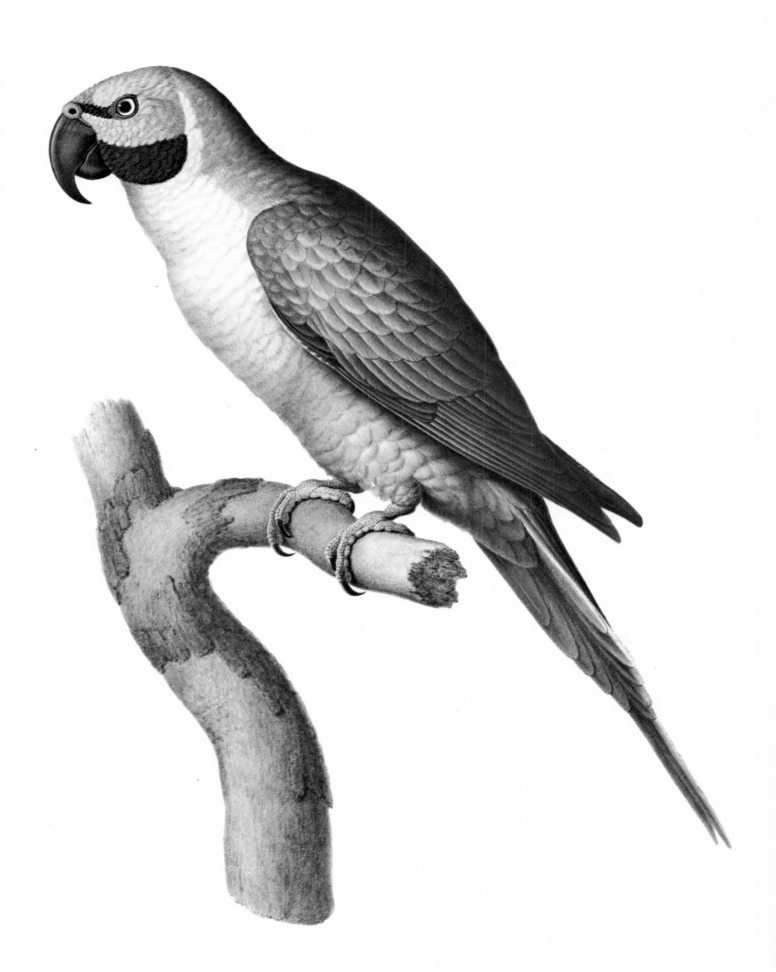

Common Gull
(Larus canus)

The Common Gull inhabits the coastal regions of the cold seas of the northern hemisphere such as the Baltic and the Atlantic Ocean. It often moves away from the coast and goes inland where it nests in colonies on heathland and hillsides. It is a partial migrant and in winter it makes its way westwards and southwards. Some flocks go as far as North Africa and penetrate into the Nile Valley. It is a common species, breeding throughout northern Europe, Asia and north-west Canada. In the British Isles, it breeds in Scotland and northern Ireland but occurs elsewhere only as a winter visitor.

The bird is of average size, its outstretched wing measuring from 33–38 centimetres (13–15 inches) in length. The individual shown here had not yet reached sexual maturity, as indicated by the brown plumage, the adult being, like its near relative the Herring Gull (*Larus argentatus*), white with a grey back. These two species can easily be confused, except by the experienced ornithologist, especially when in flight. The Common Gull is slightly smaller and its bill more slender and lacking the red spot. The legs and feet of the adult Common Gull are greenish, while those of the Herring Gull are flesh-coloured.

Parchment in the French National
Museum of Natural History painted by
Nicolas Robert. Vol. 83, no. 94A.

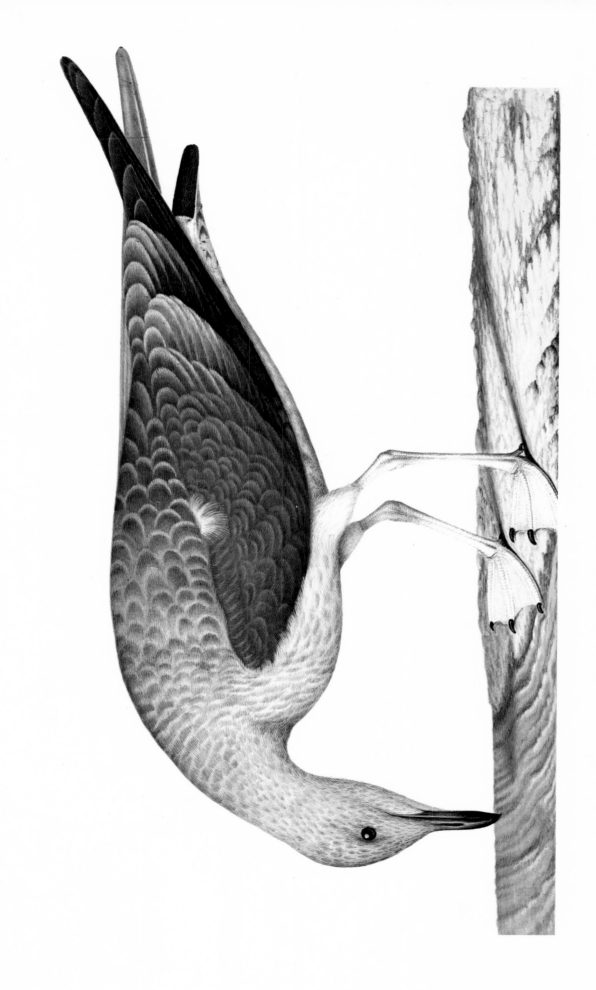

Common Cormorant

(Phalacrocorax carbo)

This tall, well-proportioned bird lives by the seashore. When it is perched on a rock or in a tree, standing almost upright, it has a very characteristic outline.

The courtship plumage of individuals of both sexes is black on the head and neck with a green and purplish-blue sheen. White filamentous feathers sprout untidily on the head and the upper part of the neck. The skin of the throat and face is white.

The Common or Great Cormorant is distributed over a vast area, from eastern North America, Europe, parts of Africa and the Middle East to Australasia. It never moves far from its home by the sea, but in eastern Europe it ventures inland, following the rivers and keeping near to the lakes. It catches fish equally happily in fresh or salt water. An excellent swimmer and diver, it is not a great flier. It builds its nest in trees, on rocks and sometimes on the ground. In winter some populations migrate, but do not undertake long journeys.

The Cormorant painted by Nicolas Robert was a young one; this is shown by the absence of white feathers and the darkish brown colour of its plumage. The Cormorants live in large flocks of about 100 individuals.

Parchment in the French National Museum of Natural History painted by Nicolas Robert. Vol. 84, no. 6.

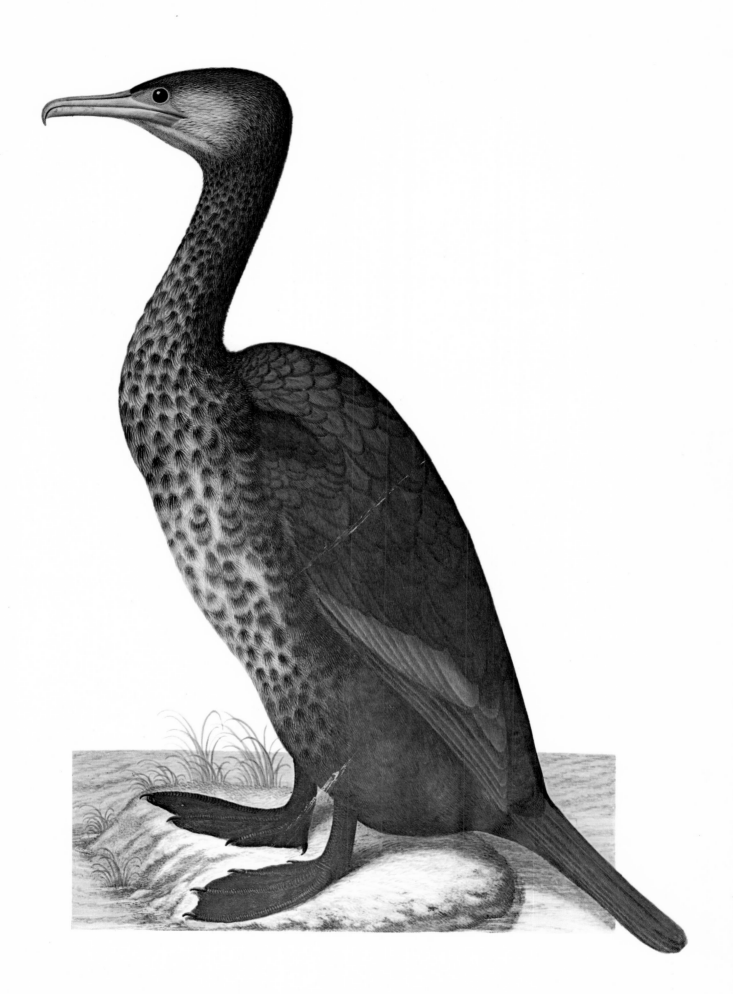

Sacred Ibis

(Threskiornis aethiopica)

This superb member of the order Ciconiiformes inhabits tropical Africa. Formerly common in Egypt, it was the object of veneration, and it is frequently found depicted in bas-reliefs and ancient drawings.

This bird has vanished from Egypt for reasons which are not clear, for its disappearance is not entirely due to excessive hunting by man. It continues to exist in the Egyptian Sudan where it is widely distributed. Its present range is Africa south of the Sahara.

Like all the ibises, it is recognizable by its long curved bill which becomes progressively more slender from base to tip. The skin of the head and neck is naked and completely black, whereas the plumage, including the tail, is white, except for the wingtips and the ornamental plumes on the lower back.

The Sacred Ibis eats grasshoppers and other insects in great quantities, as well as small reptiles, frogs, fishes, molluscs and worms, most of which are obtained by probing soft ground with the bill.

The large nest is constructed of sticks and lined with grasses and rushes, in which two or three eggs are laid. The nestlings are covered with short white down, except for the head and neck, which are black. The bill is straight and pink.

The curved bill recalled for the Egyptians the sickle used in cutting corn and they associated the bird with the Nile floods that brought fertility to the land. Hence its god-like connotation and the name they gave it, 'Father of the Reap Hook'.

Watercolour in the French National Museum of Natural History painted by R. Ruignet from a specimen brought back from Egypt by Geoffroy Saint-Hilaire, a member of the Scientific Commission which Bonaparte had attached to his army. This watercolour was reproduced in the *Description de l'Egypte*. Vol. 83, no. 70.

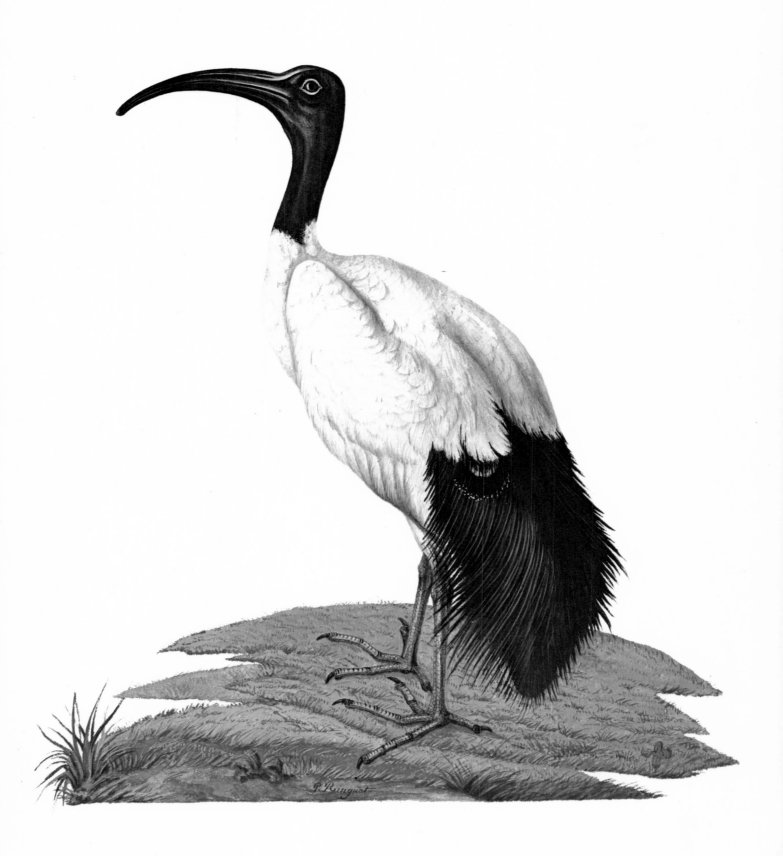
P. Ringuet

White Stork

(Ciconia ciconia)

The White Stork is – or rather was – one of the familiar birds in parts of western Europe. Every spring it faithfully returns to the place of its birth, builds a nest or, preferably, reoccupies the one it has built before.

Its main habitat is North Africa. It is not hunted anywhere and enjoys protection in Holland, Alsace and Switzerland. Despite this, it continues to decrease in numbers. This is attributed to the drainage of damp grasslands and the drying up of marshes where the Stork finds its food, consisting of tiny fish, frogs, grass snakes, molluscs and worms.

The White Stork is migratory. Those found in western Europe spend the winter in Africa after making their way along or near the Atlantic coast, then crossing the Sahara to reach Senegal or the upper Niger. The North African ones make their winter quarters farther south, in central Africa and the Ivory Coast, but sometimes do not travel so far. In summer, Storks have a wide distribution in eastern Europe, from Finland almost to the Crimea, and thence through Turkey to the Persian Gulf. In western Europe they are found in parts of Spain and Portugal, and in eastern France to Denmark.

The White Stork produces a rhythmical noise by making its beak clap, especially during courtship displays.

It nests in the tops of trees, poles or the chimneys of buildings, of which it is particularly fond, which is why it is so frequently to be found in villages, large and small, and even in towns.

Parchment in the French National Museum of Natural History painted by de Wailly in 1820. Vol. 82, no. 88.

Red-legged Seriema
(Cariama cristata)

This bird together with Burmeister's Seriema (*Chunga burmeisteri*) constitute the family Cariamidae, which is related to the bustards (Otidae). Standing erect on its long legs it has a profile similar to a long-legged wader, but its strong beak, curving downwards at the tip, recalls that of a raptor or a Secretary Bird. One can see in the seriemas traces of their remote ancestor, the gigantic *Phororhacos*, a flightless bird 2 metres (6·5 feet) tall, which roamed the vast plains of Patagonia during the Miocene period.

The seriemas are mainly walking birds and fly, clumsily, only when necessary. They live alone or in pairs and are particularly well adapted to open semi-desert spaces. Their very varied diet includes insects, seeds and leaves. They also kill small mammals and reptiles, including snakes, which are beaten on the ground with the beak to soften them before being swallowed.

Groups of seriemas on the move keep in touch by uttering high-pitched calls. These calls increase in intensity during courtship when the male goes in for elaborate displays similar to those of the bustards. They build a rough nest among low-growing bushes, 1·5–3 metres (5–10 feet) from the ground, and in it they lay two buff-coloured eggs with reddish-brown markings. During the twenty-five days of incubation, the colour fades to off-white. The dark chicks, covered with down, remain in the nest until well-grown, being tended by both parents.

The seriemas inhabit South America and are found in Brazil, Paraguay and northern Argentina.

Parchment in the French National Museum of Natural History painted by Nicolas Huet in January 1819. Vol. 82, no. 40.

Red-breasted Merganser

(Mergus serrator)

The Red-breasted Merganser is probably the finest duck in northern Europe. It has a long, thin, vermilion-coloured bill and its legs, which are not as short as those of the true ducks, are a vivid red. The feathers at the back of the neck form a long spiky double crest. The male shown opposite has a multicoloured plumage, while that of the female is a drab greyish brown with a chestnut head.

Instead of fitting into each other like those of true ducks, the mandibles simply rest one on top of the other; the horny layers of tissue on their edges, which go across from side to side, can be seen from outside.

This bird chiefly frequents coastal regions and the banks of rivers and it eats mainly fish. It builds its nest in vegetation which grows close to the marshes where it obtains its food. It also nests among boulders, on the wooded banks of lakes and the marshlands of the tundra.

The Red-breasted Merganser's breeding range is circumpolar, stretching across the northern part of Asia, Europe and North America. Several communities are non-migratory.

Parchment in the French National
Museum of Natural History painted by
Nicolas Robert. Vol. 84, no. 83.

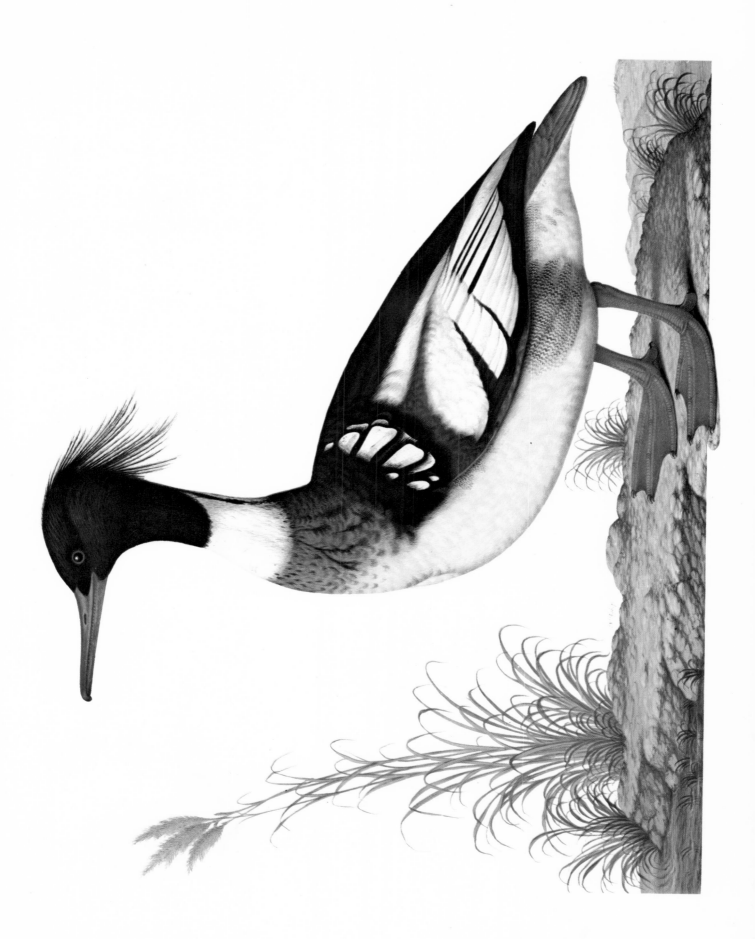

Lapwing
(Vanellus vanellus)

Lapwings live in large flocks in meadows. They feed chiefly on earthworms and the grubs of insects which they discover by probing the ground.

They also frequent damp grassland and marshy ground near the coast. Only rarely do they perch. When they take flight they utter a characteristic sound, 'peewit', which gives them their alternative vernacular name of Peewit. Another name is Green Plover.

In the breeding season the males perform strange acrobatics. In full flight they roll over and over like an aircraft in a spin, when their wings make a muffled noise, a drumming, which is a characteristic sound of spring in the temperate regions of Europe and Asia which they inhabit.

The Lapwing makes a scrape in the ground, lines it with grass and reeds, on gently rising ground in the meadows, or in the marshlands. At each hatching there are three or four pear-shaped, olive-coloured eggs, with dark blotches which often run together at the larger end. Incubation lasts about three weeks. Newly hatched chicks are strong enough to follow their mother and scratch around for food.

Parchment in the French National Museum of Natural History painted by Nicolas Robert. Vol. 82, no. 31.

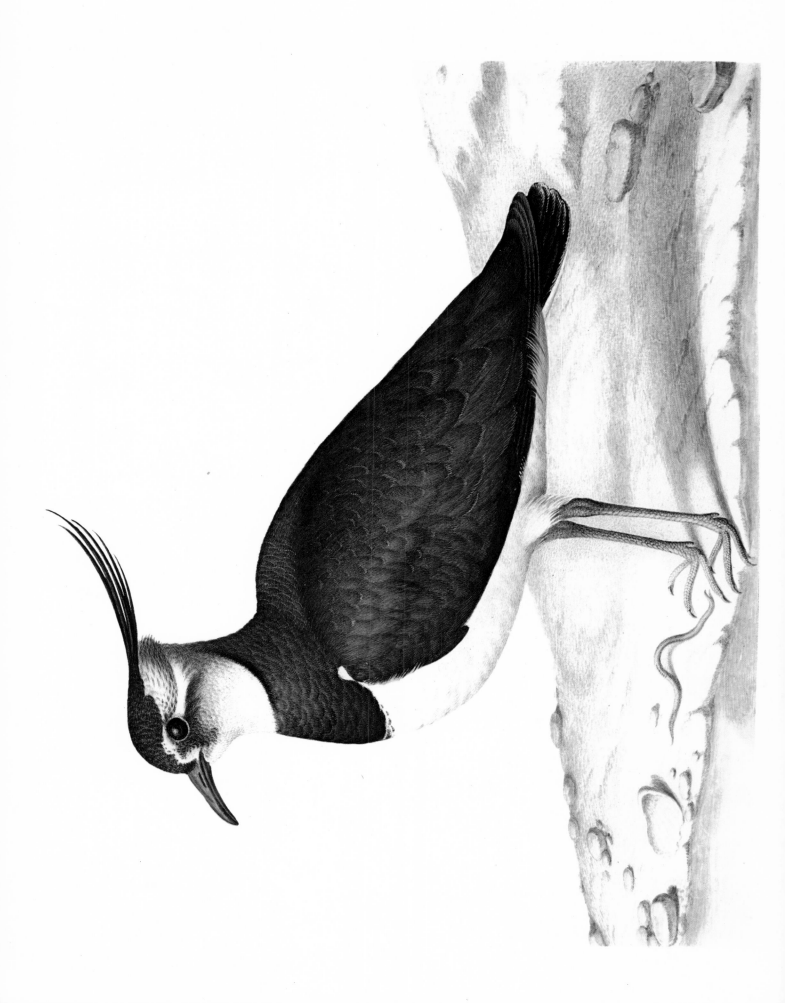

European Bee-eater
(Merops apiaster)

This bird belongs to the order Coraciiformes, which embraces species remarkable for the beauty of their plumage, among which are bee-eaters, kingfishers, rollers and hoopoes.

The bee-eaters are fairly gregarious; they dig out their nest tunnels near to one another in embankments or even in gently sloping ground. The eggs, from four to eight in each nesting, are globular in shape and entirely white. The nidicolous chicks, which are naked at birth, need a fairly constant temperature which the nest-tunnels provide.

They often perch on dead branches and telephone wires. The colour of their plumage is very striking, with chestnut and gold upper parts and a sea-green underside.

The European or Common Bee-eaters spend the summer in Mediterranean countries, and parts of Russia and North Africa. In winter they migrate to north-west India and regions lying south of the Sahara, as far as South Africa.

Although their beak is not adapted for this kind of hunting the bee-eaters take insects (the basis of their diet) on the wing, notably the Hymenoptera. On the ground they eat crickets for which they show a strong partiality.

Parchment in the French National
Museum of Natural History painted by
Nicolas Robert. Vol. 80, no. 31.

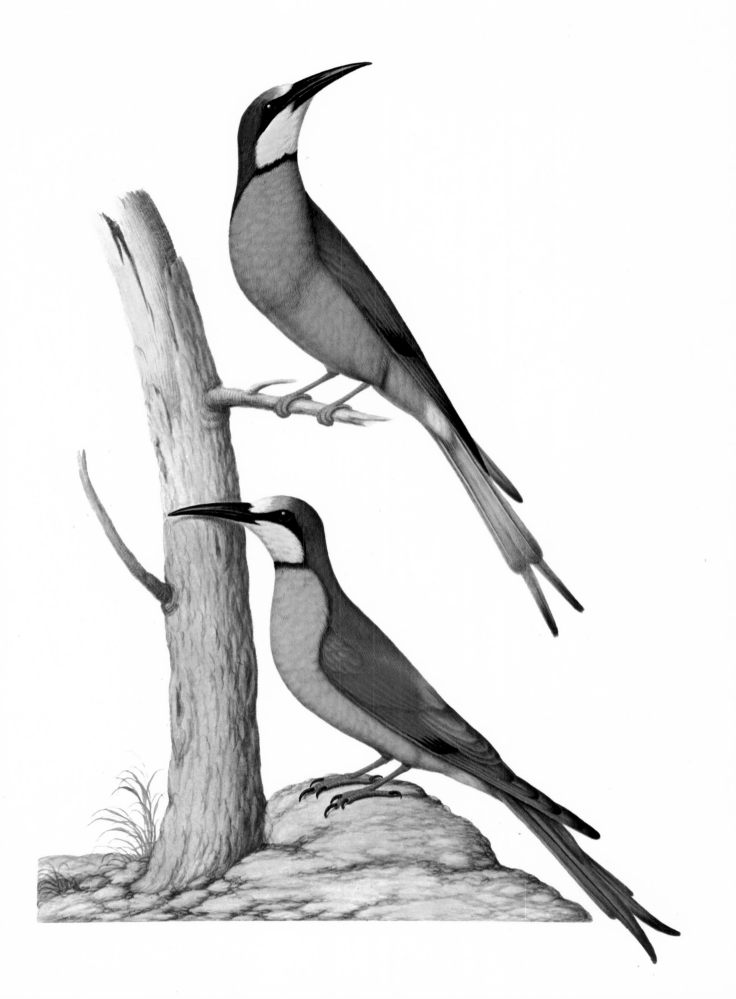

Greater Pied Kingfisher
(Ceryle lugubris guttulata)

This kingfisher is a subspecies of the Pied Kingfisher, 40 centimetres (16 inches) in length and a giant among kingfishers. Its plumage lacks the metallic sheen of other members of the family Alcedinidae. This bird, which is a native of the eastern Himalayas, is reputedly rare. It lives near fast-running streams in hilly, forested country and its reputation for being rare is probably more the result of its extremely shy disposition, making it difficult to observe. It builds a solid nest on the banks of rivers, with mud mixed with plants, fixed to large stones or rocks. This structure resembles a swallow's nest both in its positioning and in the materials of which it is made, but is on a larger scale.

Like most of the Alcedinidae, the Greater Pied Kingfisher feeds mainly on fish.

The Lesser Pied Kingfisher (*Ceryle rudis*) of Africa and southern Asia was depicted in tomb paintings of Ancient Egypt nesting on open platforms. This may have been the result of artistic licence but it is more likely that there has been a change in the bird's habits, for it now digs a tunnel with a nesting chamber at the end, as in the more familiar kingfishers. One reason for believing in the possibility that such a change in behaviour may have occurred is that its near relative, the Greater Pied Kingfisher, does not tunnel. Another is that the Lesser Pied Kingfisher removes the eggshells from the burrow after the eggs have hatched, an action usually associated with hiding the whereabouts of the nest and quite unnecessary in tunnel-nesting birds.

Watercolour taken from John Gould's work: *Century of Birds from the Himalaya Mountains*, plate no. 5, London, 1832.

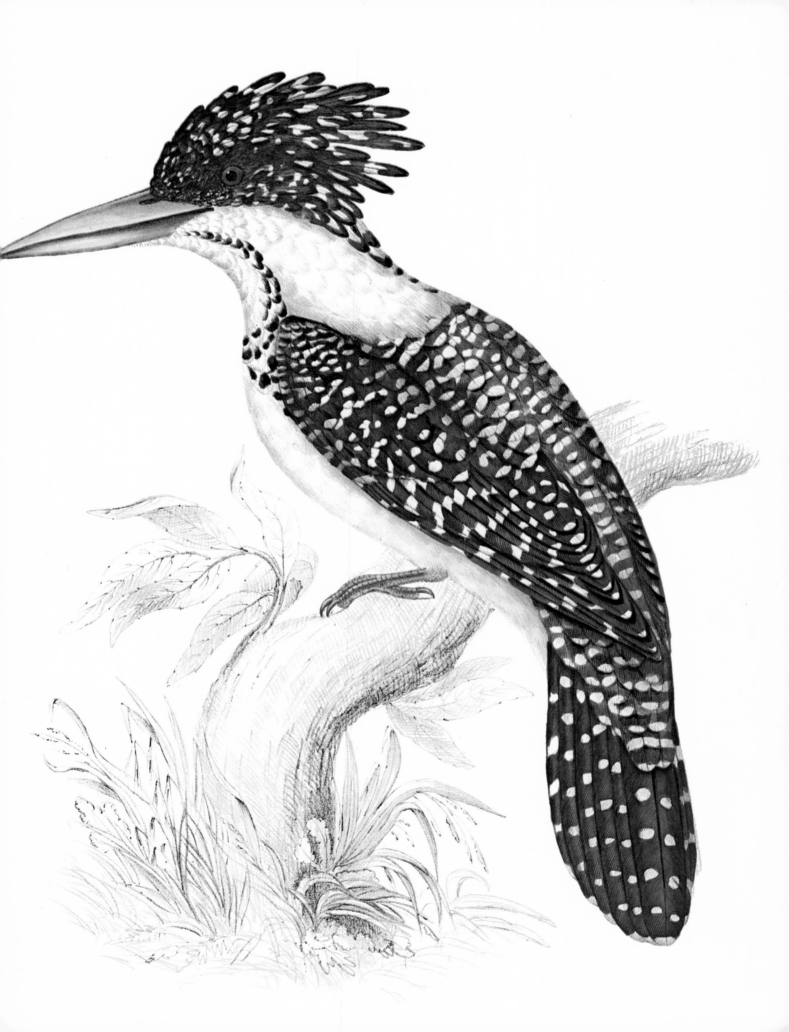

Crested Pigeon

(Ocyphaps lophotes)

The Crested Pigeon is found over practically the whole of Australia except for the extreme east. Throughout its range it keeps within flying distance of water which it visits half-an-hour after sunrise, when it fills its crop with water before feeding. Some individuals may come to water again in the evening. This pigeon also wades into the water, up to its breast, although it has never been seen to bathe, except in the usual manner of pigeons, in rain with tilted body and one wing held vertically.

Seeds are its main food but green shoots and small bulbs are sometimes taken.

Crested pigeons associate in pairs or small flocks of up to thirty but much larger flocks, up to 1000 or more, may come together where food is abundant. The birds roost in trees with thick foliage. Their flight is swift, with wingbeats and glides alternating, the wingbeats producing a distinctive whistling. One of its several vernacular names is Whistle-winged Pigeon.

The nest is the usual flimsy structure, characteristic of pigeons and doves, and in this two white eggs are laid. Breeding may occur at any time of the year.

When visiting water the Crested Pigeons behave like African game suspecting a lion ambush at the waterhole. The pigeons land in a tree or shrub near the water's edge and show signs of apprehension. Not until one has plucked up courage to fly down and drink do they all descend.

Watercolour taken from the work by Pauline de Courcelles and Florent Prévost entitled *Les Colombes*, Vol. II, Paris, 1838.

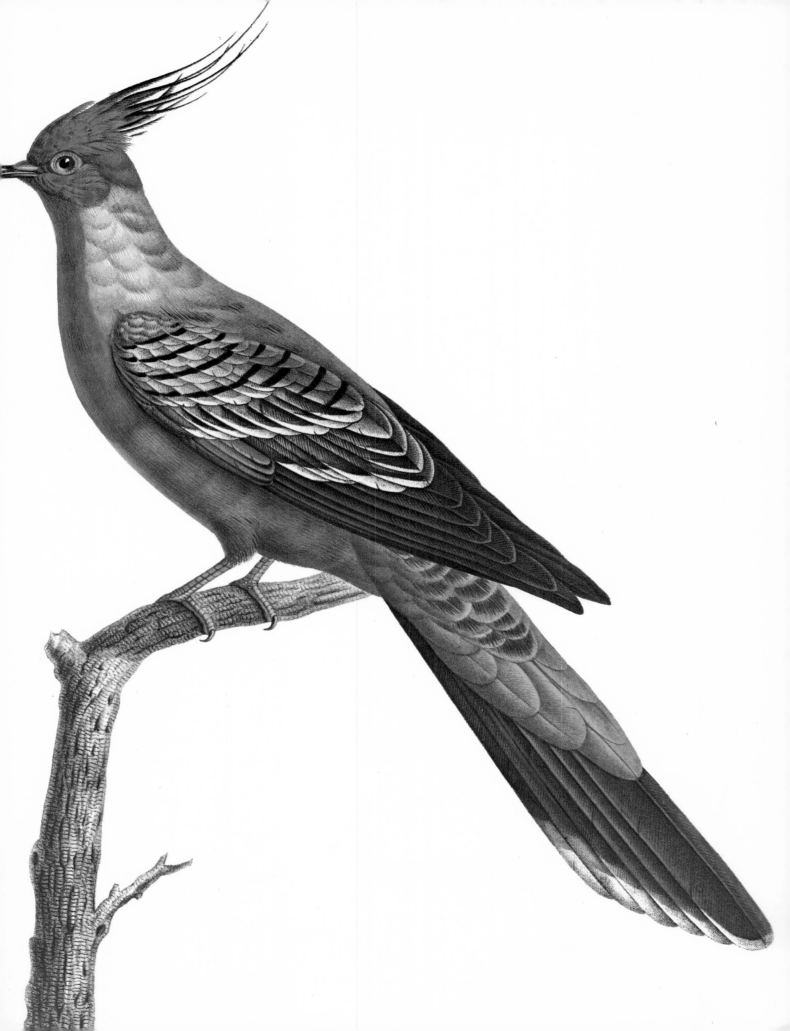

Cuvier's Toucan
(Ramphastos cuvieri)

The Toucans or Ramphastidae inhabit the forests of tropical America. Their enormous bills, disproportionate in relation to their body, are broad at the base and curved at the end. This gives them a somewhat ludicrous appearance, which is offset by the bright colours of their plumage. This prominent hollow bill, which in some species is brightly coloured, is so light in weight that it is not an encumbrance for the bird.

Cuvier's Toucan, so beautifully depicted here by Huet, lives in the Amazon region in small groups. Its chief source of food is fruit and it is capable of ingesting a peeled banana in one swallow. It also feeds on young snakes, fledglings and insects.

The toucans resemble the Old World hornbills, but they belong to the order Piciformes, whereas the hornbills or Bucerotidae are classed among the Coraciiformes. The two groups are fruit eaters, nest in tree hollows, have bills of enormous size and occupy similar ecological niches in the forests.

Although so brightly coloured, toucans are not conspicuous in their natural habitat, except when they break cover and fly for short distances across forest clearings. In flight, the wings beat six or more times followed by a short glide on outspread wings, the bill dipping during a glide as if its weight were pulling the bird down. Once in the cover of trees again, the outline of the perched bird is broken by the patches of colour and hard to see in the sun-flecked upper branches.

Parchment in the French National
Museum of Natural History painted by
Nicolas Huet in May 1809. Vol. 80,
no. 58.

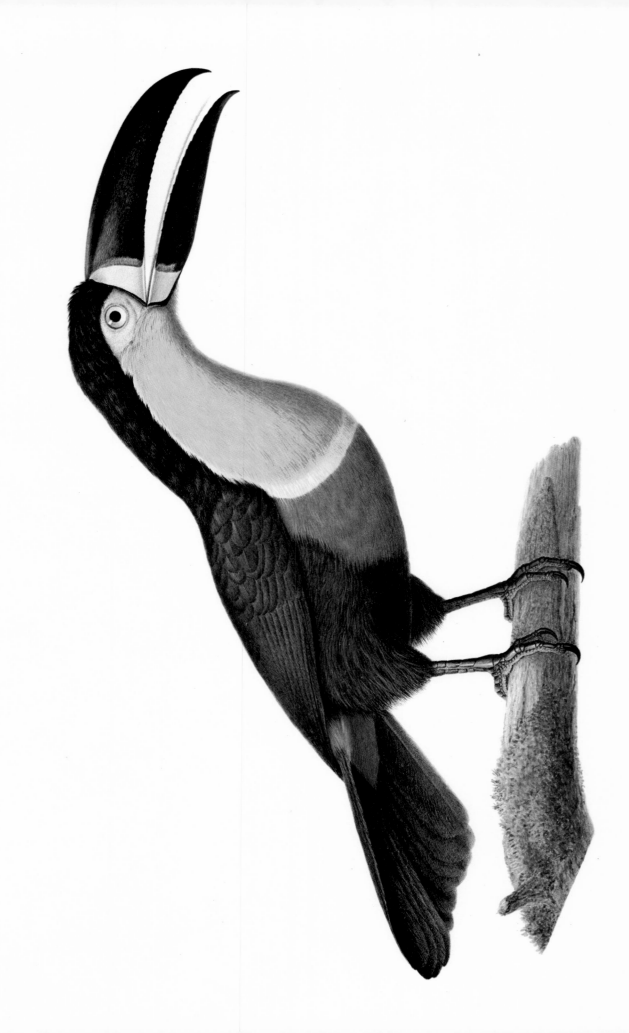

Swallow-tailed Hummingbird, Half-mourning Hummingbird

(*Eupetomena macroura* and *Melanotrochilus fuscus*)

These two hummingbirds inhabit Brazil. The bird at the top of the engraving is a female Half-mourning Hummingbird (*Melanotrochilus fuscus*) and the one below is a male of the Swallow-tailed Hummingbird (*Eupetomena macroura*).

The former belongs to a species which is less richly adorned than the majority of hummingbirds. It inhabits eastern Brazil and is a frequent visitor to flower gardens on the outskirts of Rio de Janeiro, Santa Teresa and elsewhere. Members of the genus *Melanotrochilus* make their homes in nests built in old wasp nests in trees.

The Swallow-tailed is a sturdy hummingbird widely distributed in the Guianas and in eastern Brazil. It is not very fussy about its choice of habitat. The coastal 'serras', gardens and the gallery-forests are all equally suitable. Its territorial behaviour is pronounced; it does not tolerate intruders in its domain. This hummingbird flies in a lively manner – an aerial acrobat, it is continually making sharp turns, diving and hovering. It sucks nectar from flowers but also captures many small insects. Poised on a branch it remains on the lookout and when a fly or a little butterfly comes within reach it springs, as it were, on its prey, which it seizes on the wing.

Parchment in the French National
Museum of Natural History painted by
Nicolas Huet. Vol. 80, no. 19.

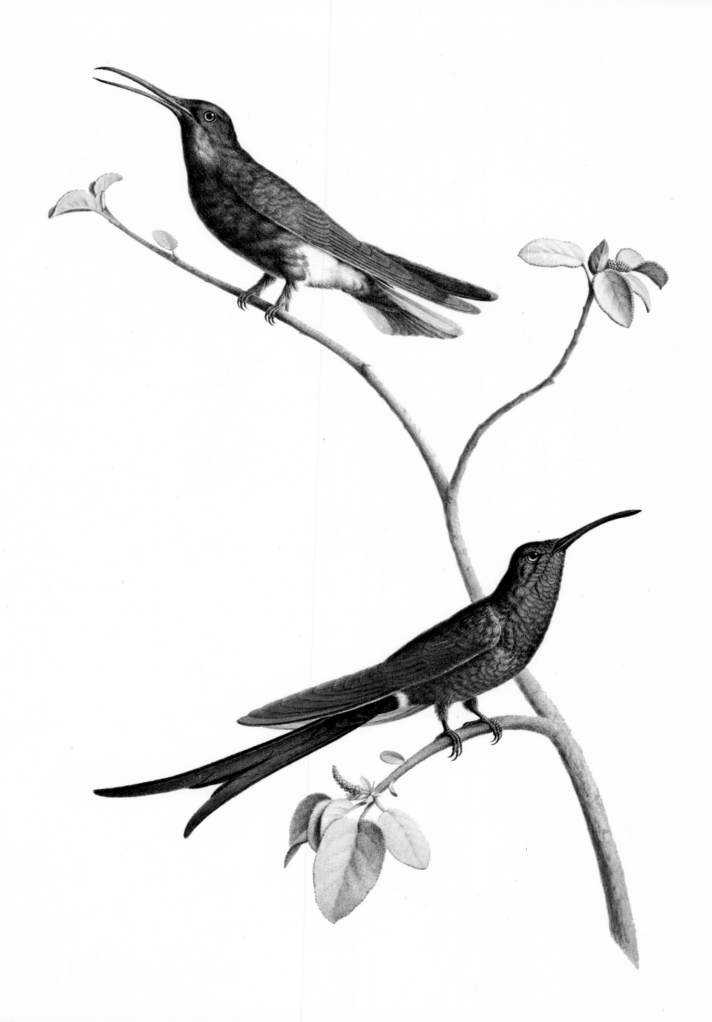

Galah

(*Kakatoe roseicapilla*)

The handsome Galah or Rose-breasted Cockatoo belongs to the fauna of Australia. It is found throughout the continent except for two wide stretches of territory running along the western and eastern seaboards. It is regarded as being accidental to Tasmania. It inhabits open spaces and savannahs with sparse tree growth, but also has a liking for pasture land and hedgerows.

It forages about on the ground for the seeds of grasses, which it consumes in large quantities. It has been calculated that a population of 5000 Galahs would consume from 25–35 megagrams (tons) a year, exercising a not inconsiderable effect on the re-seeding of pasture land in times of drought. It is therefore regarded as a pest by farmers.

It builds its nest in tree hollows. Not far from its nest site it deposits rotting wood and bark taken from the trunk and the edge of the nest and some twigs. The lot, more or less chewed up, is strewn on the ground.

The maximum lifespan of this cockatoo is probably around forty-seven years. The Galahs are very social and sometimes come together in thousands by the water's edge. The young are fed by their parents, which regurgitate the contents of their crop into the gaping beaks of their nestlings. The female lays twice a year, four to five eggs at a time. If it is well-trained the Galah can become proficient in repeating words.

Parchment in the French National Museum of Natural History painted by Huet in November 1815. Vol. 80, no. 86.

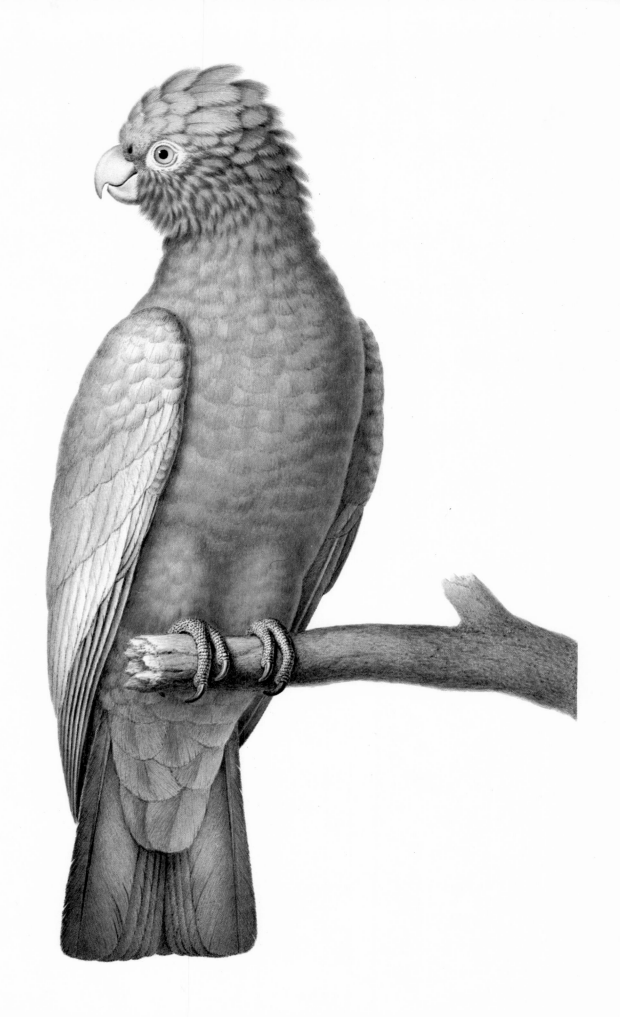

Blue Jay
(*Cyanocitta cristata*)

The Blue Jay is one of two species of *Cyanocitta*, the other being Steller's Jay (*Cyanocitta stelleri*). The Blue Jay inhabits the temperate and tropical zones of North America, from eastern and central Canada southwards to Florida. It lives in dense woods and clumps of trees, especially conifers, and builds its nest of grasses and twigs up to 8 metres (26 feet) from the ground, in the forks of branches. It lays between three and five eggs, sometimes six or seven, and, in general, breeds twice a year. The incubation, which both male and female share, lasts from fifteen to seventeen days.

The Blue Jays, like the other jays, eat a wide range of food, including seeds, fruit, insects, spiders, molluscs, earthworms and eggs. Fish and young birds are also taken, and one Blue Jay was observed catching and eating bats in daytime. However, only twenty-five per cent of its food is animal and whether the bird is considered harmful or not depends upon the crops grown in its particular locality.

Blue Jays tend to come together in small groups outside the breeding season. Should they settle and feed regularly in one area, they form hierarchies so long as they remain in that place, as contrasted with nomadic foraging. In these hierarchies males tend to be dominant over females and, as in all such instances, rank is determined by fighting, or at least by aggressive display, hence the name peck order for such hierarchies. The crest varies in size from one individual to another and size of crest is believed to be important in deciding and maintaining seniority.

Watercolour by Barraband engraved
by Pérée, taken from François
Levaillant's work: *Histoire naturelle des
Oiseaux de Paradis*, Vol. 1, plate 45,
Paris, 1806.

Golden Cock-of-the-rock
(Rupicola rupicola)

This magnificent bird, which is a dazzling orange-red in colour, lives in the forests of Guyana and the Amazon region. The male, shown here, has a crest of feathers arranged like a fan on the front of the head. The female has a rather less ornate plumage, being a uniform brown in colour.

When the courtship season arrives, the males congregate together and take over a piece of open ground which is cleared of dead branches and other debris, most frequently beneath the trees where the Cocks-of-the-rock come to look for their food. The display usually takes place in the morning. An old cock bird sets things moving by dropping from a branch on to the ground. From early dawn he performs great leaps in one spot and alternates these with static poses, with his wings spread and his tail stretched out in the shape of a fan. First one, then all the other males (up to seven or eight) imitate him and perform their leaping dance, holding their static poses for several minutes on end.

The meaning of this pantomime is not clear. It could be a courtship display to excite the females and to invite them to mate, or the sight of the display might stimulate first the hyophysis and secondly the ovary and the laying of eggs. This is no more than guesswork because no adequate study has yet been made of the role of the females at the leks, as these male display grounds are called. The puzzling factor is that the males continue to dance when the females have laid and incubated and the eggs have been hatched.

Watercolour taken from François
Levaillant's work: *Histoire naturelle des
Oiseaux de Paradis*, Vol. 1, plate 51,
painted by Barraband and engraved by
Gremillet.

Houbara Bustard
(Chlamydotis undulata)

The Houbara has a crest and ruff as have most of the bustards. It inhabits stony or sandy steppes with poor or stunted vegetation. In North Africa, where it is still quite frequently found, it readily makes its way into fields of cereals or stubble and picks up the grains which have dropped there during the harvest. It is also known in central Asia, where it has a marked preference for the vast expanses of the steppes. Typically, however, it is a bird of stony deserts and barren steppes, feeding on the shoots, berries and seeds of desert shrubs.

The Houbara has ornamental feathers, more developed in the male than in the female, which cover it with an elegant 'cape'.

The bustards are fast runners, but with their short wings they fly rather clumsily. Their sand-coloured upper parts merge with the ground and make them difficult to detect.

Little is known of the Houbara's courtship display apart from the male fluffing out his neck frill and raising and spreading his tail to expose the white-tipped feathers. The nest is a scrape in bare sandy soil or among stones, in the shade of a shrub. Two to three, rarely four, eggs are laid. The male departs as soon as the eggs are laid, to join other males and non-breeding females well away from the nesting area.

The chicks grow quickly, fledging in about a month, when they gather in flocks.

Parchment in the French National Museum of Natural History painted by Maréchal, in 1793, from a specimen brought back by the botanist R. Lonfiche Desfontaines, who, during a journey lasting two years, also collected more than 300 species of new plants. Vol. 82, no. 19.

moitié de la grandeur.

Maréchal
1793

Satyr Tragopan
(Tragopan satyra)

The tragopans are Asiatic members of the order Galliformes. Many birds of this order originated in Asia, from India to southern China, including the peacocks, pheasants and domestic fowls which have produced an abundance of species, remarkable, for the most part, for the beauty of their forms and their plumage.

The tragopans are related to the pheasants, but are distinguished from them by the shortness of their tails and by the naked and brightly coloured cheeks and wattles which decorate the heads of the adult males. The females have a dull, brownish plumage.

The tragopans inhabit mountains at the upper limit of forest regions (between 3000–5000 metres, 10000–16500 feet). The shrub zone, with rhododendrons and Whortleberries, is their favourite domain. In the Asiatic forest zone they are replaced by the pheasants. They feed on berries, seeds and insects.

The bird depicted by Gould is an adult male Satyr Tragopan which has not fully acquired its final plumage and whose horn-like erectile feathers, caruncles and wattles are strongly pigmented with blue.

The tragopans look for their food on the ground but perch when sleeping.

Watercolour taken from John Gould's work: *Century of Birds from the Himalaya Mountains*, plate 62, London, 1832.

Grey Jungle Fowl
(Gallus sonneratii)

This superb fowl was named after Sonnerat, a seventeenth-century French naturalist and traveller, who made it known in Europe and described it in his book *Voyage aux Indes Orientales et a la Chine* (1782, Vol. II p. 153, plates 94 and 95). Also known as Sonnerat's Fowl, this bird inhabits south and west India. It proudly flaunts a comb with a serrated edge, and two magnificent blood-red wattles hang under its throat. The feathers in its ruff are tapered, and tinged with golden yellow with a brown bar in the middle. Its breast is covered with grey feathers which have a white streak surrounded by black in the centre. It is an aggressive bird, and uses its sharp-pointed spurs freely.

Since the Grey Jungle Fowl was the first bird resembling the Domestic Fowl to be observed in the wild state by Europeans, Sonnerat considered it to be the ancestor of the domestic breeds. However, in various regions of south-east Asia there have since been found other Galliformes which are probably more closely related to the domesticated fowl, such as the Red Jungle Fowl (*Gallus gallus*), which lives in the wild from India, the Himalaya region and south-east Asia generally, east to Java. This is generally regarded as the ancestor of all domestic poultry. *Gallus gallus* and *Gallus sonneratii* mate readily and produce fertile hybrids, but only in captivity. Their hybrids have never been recorded in the wild.

Parchment in the French National Museum of Natural History painted by Huet the Younger in August 1816 from a specimen in M. Dufesne's private natural history collection. Vol. 81, no. 25.

Red and Yellow or Scarlet Macaw

(Ara macao)

The macaws are, together with the cockatoos, the largest of the parrots. They live in the forests of Central and South America.

Their tail, which is longer than the body, is graduated and tapering. Their cheeks are not feathered and the skin which covers them, generally white in colour, extends as far as the bottom of the lower jaw. It gives them a very characteristic disdainful or mocking expression. The large bill is capable of some movement where it joins the skull, as is the case with nearly all the parrots. The bird uses it to cling when it is climbing along branches, and in combination with the strong muscular tongue gives it considerable manipulative ability.

Macaws are sociable birds and form groups of up to several dozen individuals. When we were coming down the Amazon recently more than twenty Blue and Yellow Macaws (*Ara ararauna*), busily stripping a tree of its fruit, raised their heads in surprise. What a riot of colour when, with wings outstretched, they flew off into the rays of the sun which was low on the horizon! The whole flock, chattering and uttering shrill cries, disappeared leaving behind in our dazzled eyes the impression of a long streak of colour.

Macaws lay their eggs in hollows in trees. They adapt quite well to captivity and possess the ability to imitate the human voice, but to a lesser extent than, for example, the African Grey Parrot (*Psittacus erithacus*).

Parchment in the French National Museum of Natural History painted by Nicolas Robert. Vol. 80, no. 63.

Twelve-wired Bird of Paradise
(*Seleucidis melanoleuca*)

This bird of paradise is native to New Guinea, throughout the coastal regions, often near the shore, in sago palm and mangrove swamps. It belongs to the long-tailed tribe, characterized by a slender beak and a medial bone in the upper jaw which is longer than the tarsus.

The Twelve-wired Bird of Paradise has a sumptuous plumage and fine yellow ornamental plumes on each flank, the quills of some ending in long curving filaments, six on each side. The tail of these birds of paradise is quite short.

Seleucidis melanoleuca performs a strange courtship display. Facing the female perched on a low branch whom he has attracted with his cries, the male, while singing, flutters and hops from branch to branch, makes his wings vibrate, and erects and spreads out his ornamental feathers. Males have even been seen to hang head downwards from the branches of trees, as part of the display. His territory is restricted to two or three trees. The female, which has a drab plumage, builds the nest and she alone undertakes the incubation of the eggs and the care of the nestlings. The birds of paradise feed chiefly on fruit, but also take insects, tree frogs and lizards from the branches.

Bird of paradise skins have been exported for over 2000 years and the New Guinea tribesmen themselves have used the feathers for personal adornment. Fortunately, this exploitation has now been significantly reduced.

Watercolour taken from the *Histoire naturelle des Oiseaux de Paradis* by F. Levaillant, Vol. 1, plate 16, Paris, 1806, painted by Jacques Barraband, engraved by Pérée.

Great Spotted Woodpecker
(Dendrocopos major)

The Great Spotted Woodpecker or Pied Woodpecker is a climbing bird belonging to the order Piciformes. Widely distributed from Britain to Japan, it is absent from Europe only in Ireland and northern Scandinavia. Nicolas Robert has portrayed to perfection a pair of these Woodpeckers on a dead tree, from which they obtain the grubs of insects. The male has a red patch on the back of the neck.

When the courtship season begins the Great Spotted Woodpeckers, both male and female, make a drumming sound on trunks and branches by striking them with their beaks as fast as they can; this drum roll lasts about two or three seconds and can be heard 150 metres (490 feet) or more away. This could be both a mating call and a demarcation of territory.

The Great Spotted Woodpecker feeds on insects, like the other members of the Picidae family, as well as nuts and seeds. It also licks the sap which flows from holes in living trees, either conifers or deciduous, which it obtains by piercing the bark as far as the cambium from which the sap oozes out. The lime tree is often its target.

The Spotted Woodpecker rarely scratches about on the ground for food. It nests in tree hollows, where it lays from four to six greyish white eggs, marked with dark-coloured specks. Incubation lasts two weeks.

Parchment in the French National Museum of Natural History painted by Nicolas Robert. Vol. 80, no. 45.

Blue Crowned Pigeon

(Goura cristata)

New Guinea is the homeland of numerous birds with magnificent plumage. It is in its highland forests that the most beautiful birds of paradise live.

Here also, and only here, are found the largest and most attractively coloured of the pigeons – the three *Goura* species. These birds, which are the same size as a hen (*Gallus gallus*), have a plumage which is deep blue in colour and on the head a fan-shaped crest, the feathers of which vary in their arrangement from one species to another.

Crowned Pigeons inhabit forests, searching for fallen fruit and also taking seeds and molluscs.

The Blue Crowned Pigeon is found only in the north-west of New Guinea. It nests in trees, making a bulkier nest than is usual for pigeons. The single white egg is incubated by both parents for twenty-eight to twenty-nine days and the young leaves the nest at thirty to thirty-six days but is fed by the father until about fifty-six days old.

The courtship display of the male is most spectacular. He erects and spreads his tail and twists it slightly towards the hen. At the same time he half-opens his wings and lowers his head and tilts this towards the hen so that the full magnificence of his crown is displayed to her. He varies this by dancing with up-stretched wings.

From a watercolour by Pauline de Courcelles taken from the book by Pauline de Courcelles and Florent Prévost entitled *Les Colombes*, Paris.

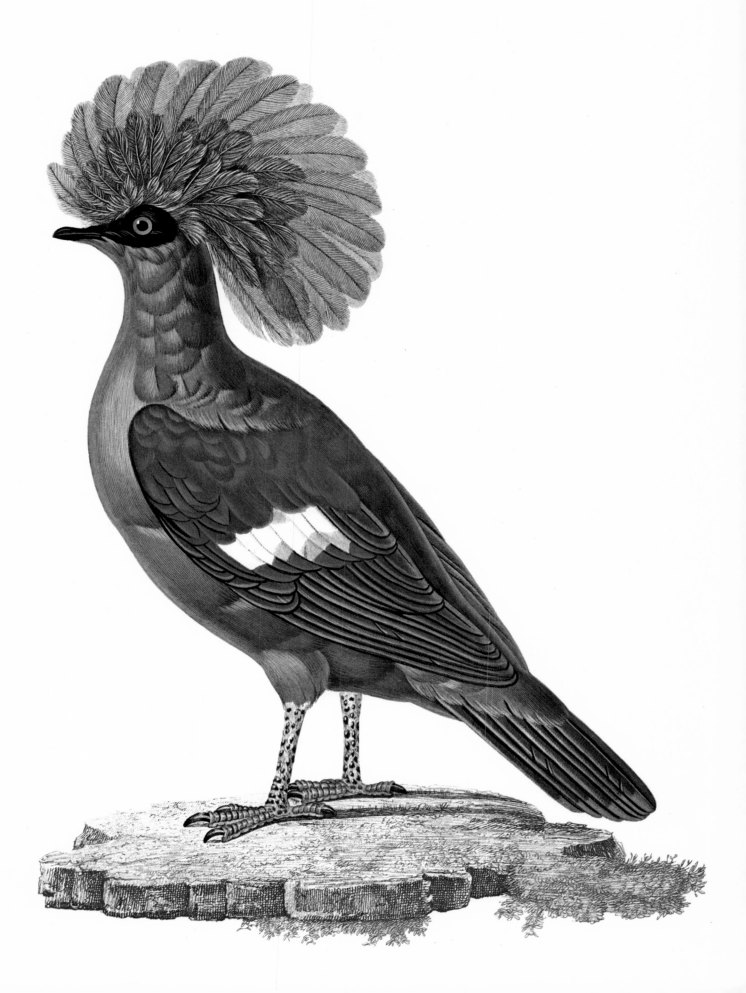

Scarlet Ibis
(Guara rubra)

This fine bird inhabits the Caribbean and Amazonian regions, where it frequents the banks of rivers and marshes.

Its bright red colour makes it conspicuous to even the most inattentive observer, so great is the contrast with its surroundings. Here is a bird which survives while scorning any attempt at mimicry or at merging with its background. Nobody seems to have a ready or satisfactory explanation why the bird should be so strikingly coloured. All we can do is recall that bright red is one of the commonest warning colours, and this may eventually prove to have some relevance. That the colour of the Scarlet Ibis is remarkable is emphasized by the words used to describe it : 'jets of flame', 'trees spattered with blood', 'essence of rubies'.

The beauty of its plumage and also its hardiness, together with the fact that it adapts itself easily to captivity, ensure that it is much in demand in zoos. The Scarlet Ibises of the Goeldi Zoo in Belem in Brazil can live half at liberty returning to their sleeping quarters in the evening. It eats almost any of the small creatures it finds in water and mud.

The individual so delightfully painted by J. C. Werner had an abnormal plumage, showing a partial albinism, a natural curiosity but one in which the real beauty of the bird has been lost.

Parchment in the French National
Museum of Natural History painted by
Jean-Charles Werner. Vol. 83, no. 2.

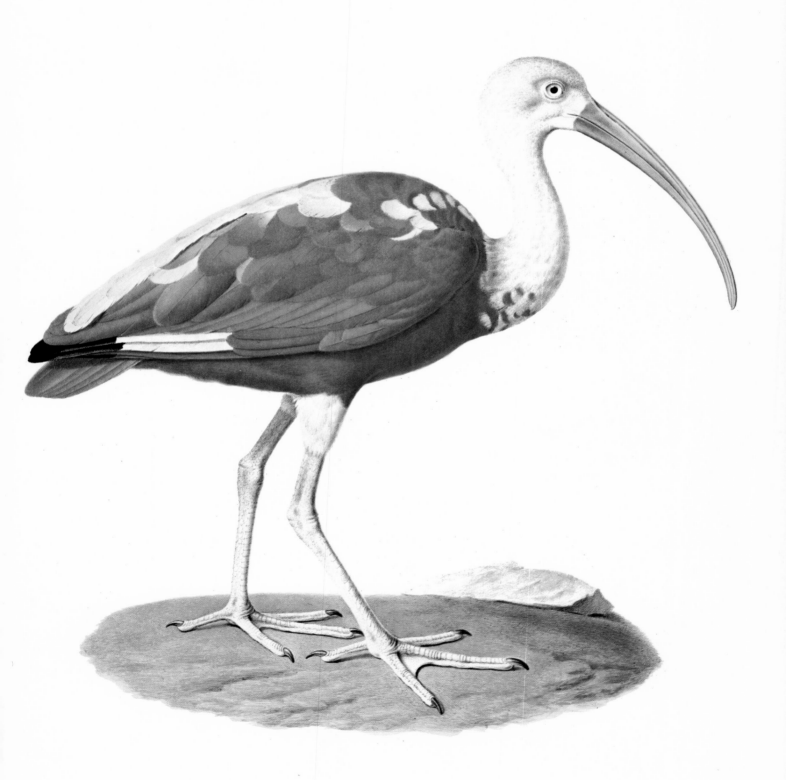

Blue-diademed Motmot
(Momotus momota)

The motmots form a family of American birds (Momotidae), classified among the Coraciiformes and not far removed from the kingfishers (Alcedinidae). In their variegated plumage green, reddish brown and black predominate. The feathers on the head are sometimes very brightly coloured.

They are found only in tropical America (except the Antilles) and are confined to thickly forested regions. They are very common in Mexico and readily adapt to the presence of man. They are recognizable by the serrated edges to their broad bills, but above all by the two long feathers at the end of their tail. These two feathers do not have vanes along the whole length of their shaft, which gives the bird a quite distinctive silhouette. When perched, motmots often swing their racquet-ended tails from side to side, like pendulums, or hold the tail tilted sideways.

The motmots are approximately the same size as bee-eaters. They feed on insects, molluscs and fruit. They build their nests in burrows in the ground. Both male and female dig, using the bill to loosen the soil which they kick back with their feet. The Blue-diademed Motmot often makes its tunnel in the side of a narrow natural pit or the side of a mammals' burrow. The nests are then hard to find. Three or four pure white eggs are laid.

The individual painted by Barraband was an adult male.

Watercolour by Barraband engraved
by Pérée taken from François
Levaillant's work: *Histoire naturelle des
Oiseaux de Paradis*, Vol. 1, plate 37,
Paris, 1806.

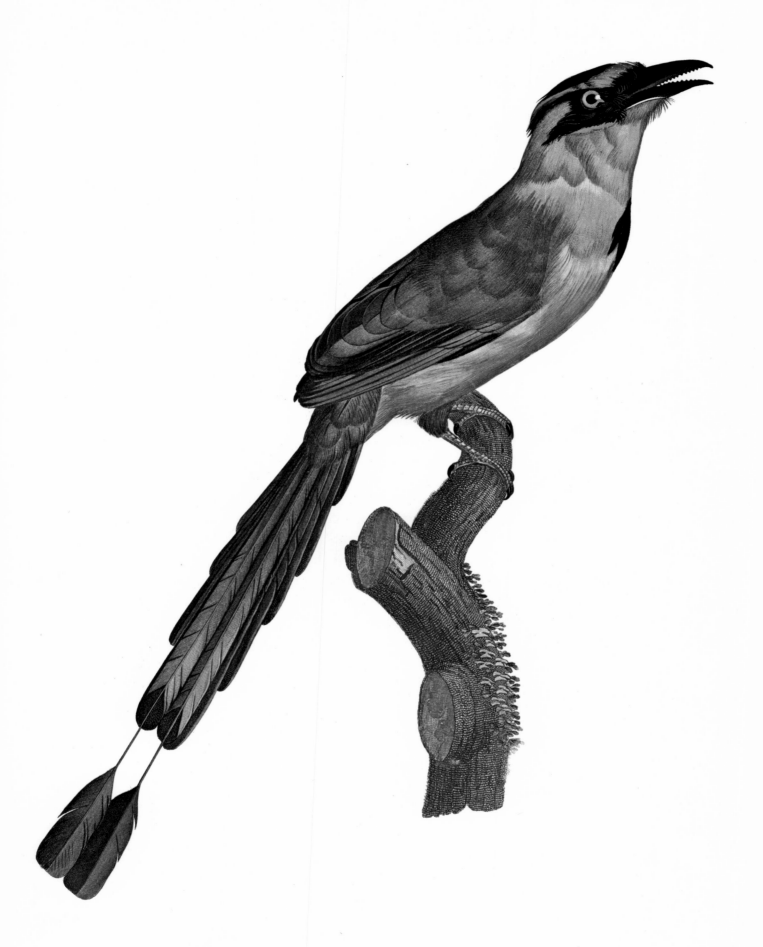

Golden Oriole
(Oriolus oriolus)

The Golden Oriole is one of the most brightly coloured of the birds occurring in Europe. The pair represented here clearly show the sexual dimorphism of the species, the female having a less richly tinted plumage than the male (above). The Oriole reaches its breeding grounds in spring (April–May) and leaves it at the end of August or the beginning of September. It migrates to tropical Africa, crossing the entire width of the Sahara.

In Europe and eastwards to central Asia, where it breeds, it is commonly found in mixed woodland and pastureland and in orchards, its favourite spot being the tops of trees. The male's song is a piercing melodious whistle, which carries a long way. The female has a weaker voice, and utters a soft mewing sound.

The nest is built in the forks of the branches of elms, poplars and aspens with fibrous materials, such as straw, horsehair, wool and hemp, woven into a network, in the meshes of which are interwoven dead leaves, strands of wool and spiders' webs. The whole forms a solid but soft cup-shaped structure. In it, the female lays four or five white eggs speckled with black dots.

The male is 24 centimetres (9·5 inches) in length. The Oriole feeds mainly on insects, particularly in spring, including hairy caterpillars, bees, bumblebees, and beetles, including cockchafers. Later in the year it turns to ripe fruit.

In parts of western Europe it seems to have become more scarce during the last twenty years, but has extended its breeding range in the same period to southern Sweden and has increased in numbers in Denmark.

Parchment in the French National
Museum of Natural History painted by
Nicolas Robert. Vol. 78, no. 75.

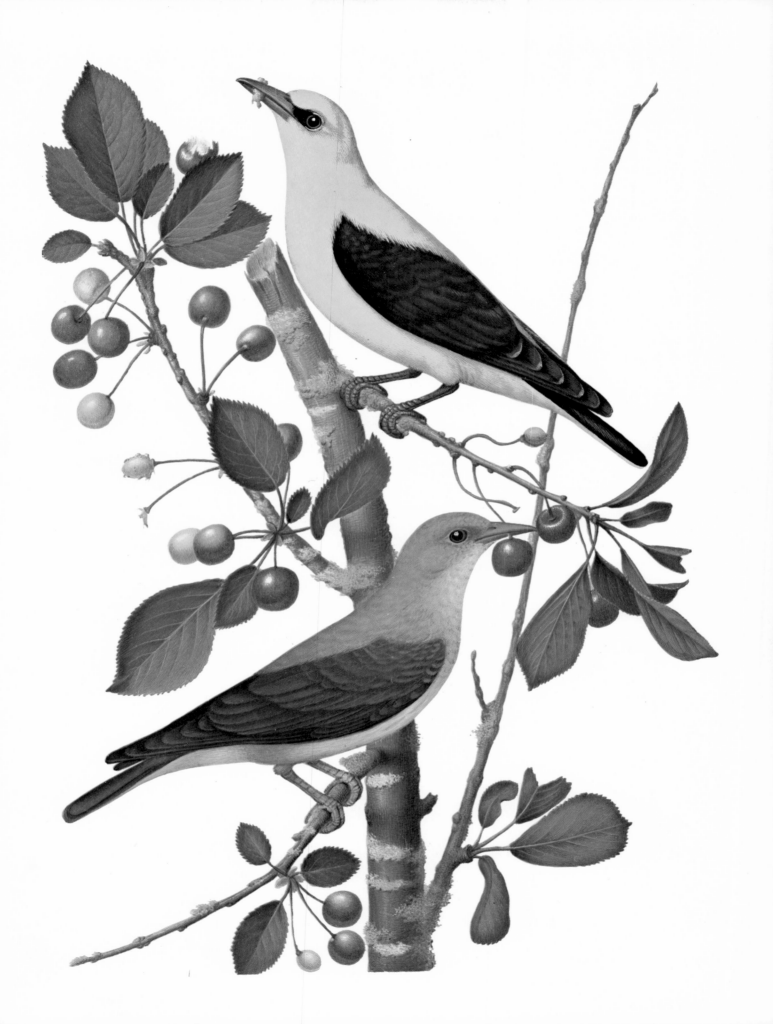

Boa Constrictor

(Constrictor constrictor)

The Boa Constrictor is a fine-looking snake of tropical America. Its reputation of being a giant among snakes is somewhat exaggerated. In fact, it does not reach the size of the Anaconda (*Eunectes murinus*) or the Reticulated Python (*Python reticulatus*). Several exceptional specimens measuring 4·5 metres (15 feet) have been noted, against 8 metres (26 feet) or more for the Anaconda and nearly 9 metres (30 feet) for the Reticulated Python, but the average size of the Boa Constrictor is from 2–2·7 metres (6·5–9 feet).

It hunts small or medium-sized mammals of the size of dogs and sheep, which it imprisons in its coils and then, by constriction, slowly stifles their breathing.

The Boa Constrictor's movements are severely hampered when it has ingested a large prey and it remains in the same spot while it digests its meal.

All Boas like warm, damp places. The suffocating heat of the great forests, alongside stretches of still water, is ideal for them.

The female incubates her eggs, from which the young emerge measuring 60 centimetres (23 inches) in length. A large female may lay nearly three dozen eggs.

Parchment in the French National
Museum of Natural History painted by
A. J. B. Vaillant. Vol. 88, no. 7.

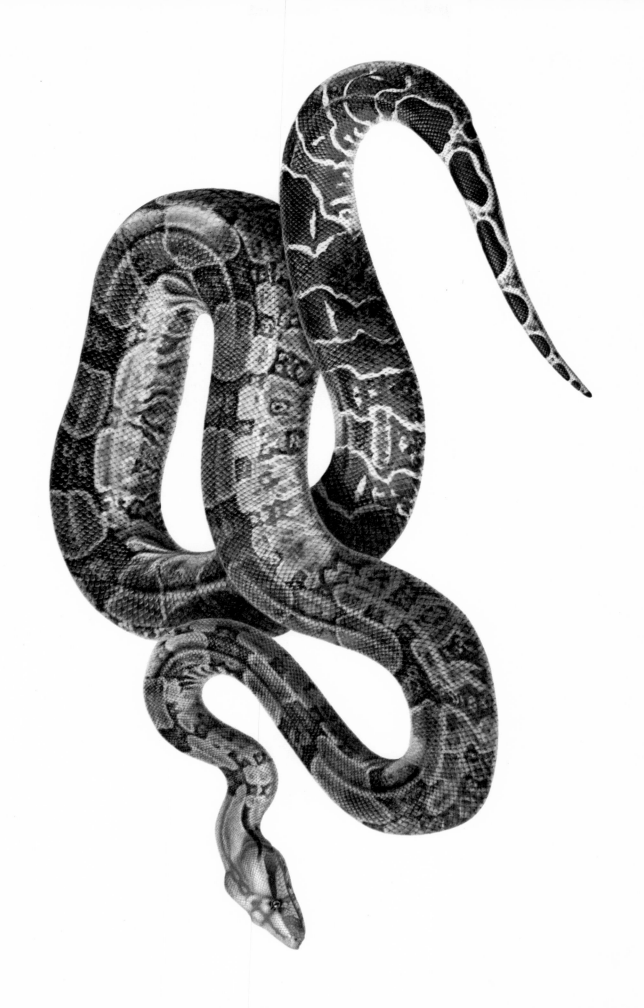

Tegu
(Tupinambis teguixin)

This large and beautiful lizard which inhabits South America belongs to an exclusively New World family, the Teiidae. Only one genus, *Cnemidophorus*, occurs in North America, all the other Teiidae inhabiting Central and South America. The Teiidae occupy in the New World the same niche as the Lacertidae in the Old.

The *Tupinambis*, of which the largest species is *Tupinambis nigropunctatus* of Brazil, move about quite happily in the neighbourhood of human habitation, where they plunder the hen houses. Their objective is not the birds but their eggs, of which they are particularly fond. Tegus are mainly carnivorous and feed on frogs, lizards, eggs and insects. They also eat leaves and fleshy fruit.

The Tegu lays its eggs deep in the ground, but on occasion Tegu eggs have been found in termite nests. Certain South American termites make their nests in trees, as much as 4 metres (13 feet) up from the ground. The walls of these nests are very hard but the Tegu is able to tear it with its claws. Once the eggs are laid the termites repair the nest, so immuring the eggs, thereby protecting them from possible predators.

Parchment in the French National
Museum of Natural History painted by
Jean-Charles Werner. Vol. 87, no. 48.

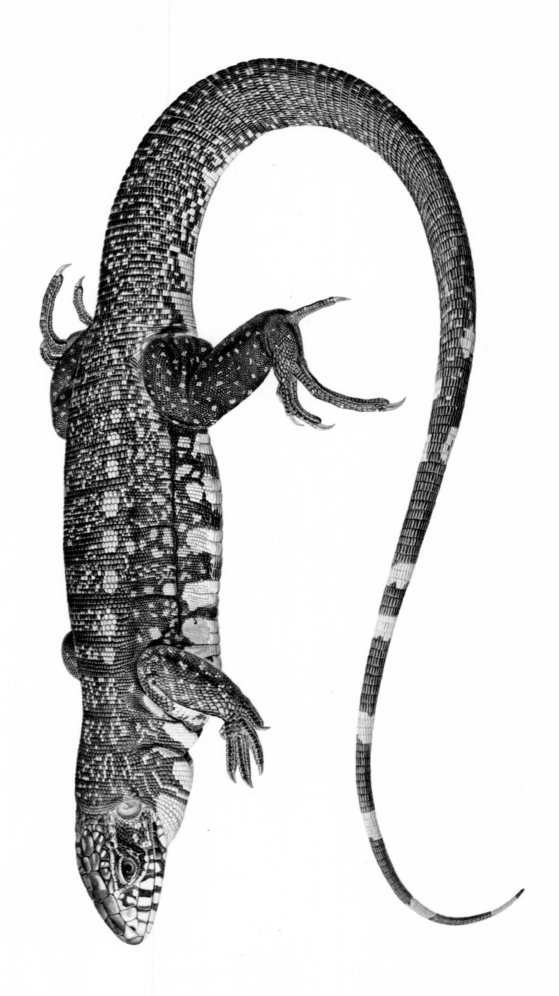

Coal Tortoise

(Testudo carbonaria)

The tortoises of the genus *Testudo* are represented in Europe, Africa, Madagascar, Asia and South America. Many island-dwelling mammals have undergone a reduction in size; for example, the fossil remains of pigmy Elephants and Hippopotamuses have been found on Mediterranean islands. Tortoises, on the other hand, have become giants, such as *Geochelone gigantea* (Seychelles Islands) and *Geochelone elephantopus* (Galapagos Islands).

Testudo of average, sometimes small, size inhabit the continents, where, despite being hunted by man, they manage to survive. Such is the case with *Testudo carbonaria*, which lives in Brazil in the dry savannas. Its shell with its darkish-coloured scales has earned it the name of 'coal-scuttle'.

It feeds on vegetation, but may also eat any earthworms and molluscs it comes across during its wanderings. Like the European Tortoise (*Testudo graeca*), the Coal Tortoise is almost exclusively vegetarian but will eat animal matter at times. There are, in fact, few vegetarian animals that will not at some time eat animal food, if only incidentally. It was this, no doubt, that led people to keeping a European Tortoise with the mistaken idea of ridding the garden of insects and slugs.

European Tortoises, probably others, will also gnaw bones, presumably for the calcium needed for their own bone growth.

Parchment in the French National Museum of Natural History painted by Nicolas Huet in 1820. Vol. 87, no. 4.

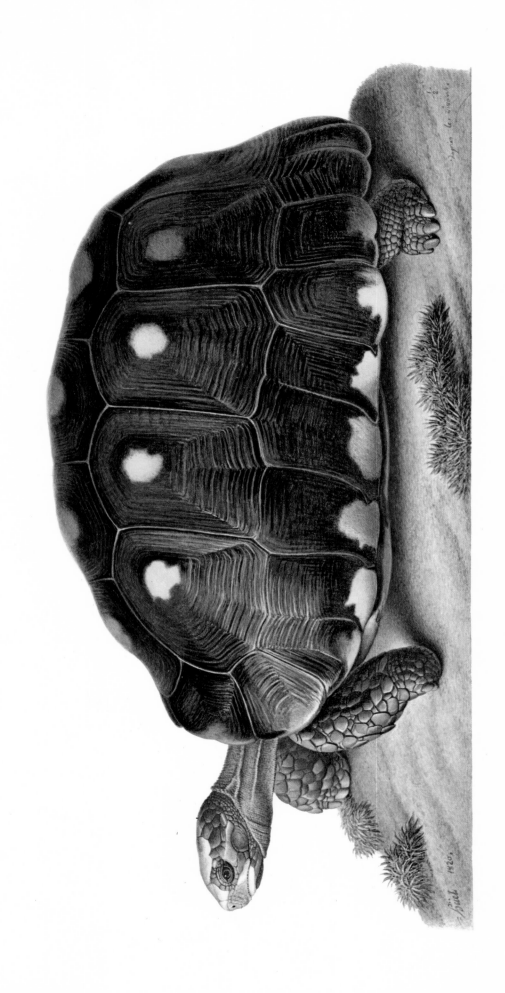

Common Iguana
(Iguana iguana)

This large and splendid lizard is one of the characteristic animals of tropical America. It usually inhabits the forests, but sparsely wooded places and the vicinity of water also suit it well.

Its eyes shine like gems. On its sides and on its dewlap the sun's rays make the tubercles (small, rounded projections) flash like emeralds. Usually it remains in a frozen attitude, like a sphinx, which hides it from the eye of the observer. However, the slightest noise from a branch broken by an intruder puts it on the alert and it disappears so rapidly, so abruptly, that it leaves only a fleeting impression on the eye.

The Common Iguana is one of the largest lizards. Some specimens measuring 2 metres (6 feet) in length have been noted.

Its body, like that of other tree-dwelling lizards, is flattened in cross-section. At the mating season, its flesh, permeated with fat, is very tender and much appreciated, particularly by the inhabitants of Nicaragua who cook it in a variety of ways and also cure it.

The Common Iguana is a good swimmer, propelling itself with its long, muscular tail. As a means of defence when attacked it uses its tail like a whip, lashing it violently at its enemies.

Parchment in the French National Museum of Natural History painted by Chazal in 1852. Vol. 87, no. 84.

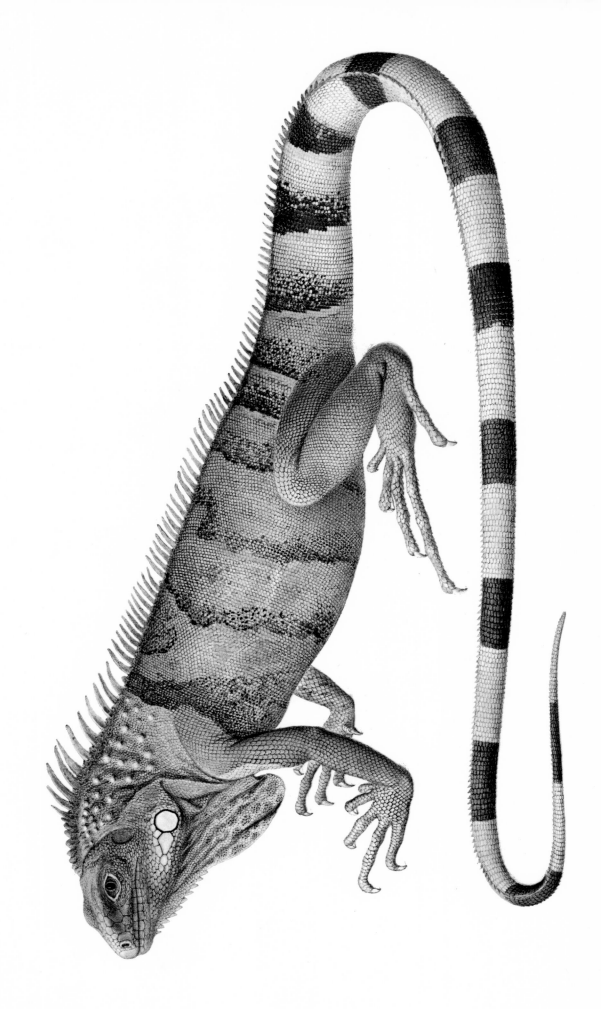

Peacock Wrasse

(Crenilabrus pavo)

The wrasses are marine fishes which belong to the order Perciformes. They inhabit coastal regions, as well as deeper waters, and are particularly abundant around coral reefs. They are brightly coloured fishes and there are numerous species in which the males and females have different colour patterns.

The Peacock Wrasse lives in the Mediterranean and in the Bay of Biscay, and measures between 15–30 centimetres (6–12 inches) in length.

Wrasses feed on such marine invertebrates as crustaceans, molluscs and worms, and some are known to eat carrion at times. Others have more specialized feeding habits, like the Saddle Wrasse (*Thalassoma duperryi*) of Hawaii. This feeds on the eyes and fins of other fishes and has protruding front teeth to carry out this gruesome habit.

The reproductive habits of many wrasses include making a nest of pieces of seaweed for their eggs. They glue the fragments together with a sticky secretion, the nest itself being sited among seaweeds anchored to rocks. The male guards the eggs.

Many wrasses, especially those of tropical seas, are well known for their sleeping habits. Some merely bury themselves in the sand. Others, especially those living around coral reefs, go to caves some distance from their feeding grounds and use these as dormitories. One, the Rainbow Wrasse (*Labroides phthirophagus*) of Hawaii, puts on a 'nightdress': it secretes a cocoon of mucus around itself before going to sleep.

Parchment in the French National
Museum of Natural History painted by
Pierre-Joseph Redouté. Vol. 92, no. 13.

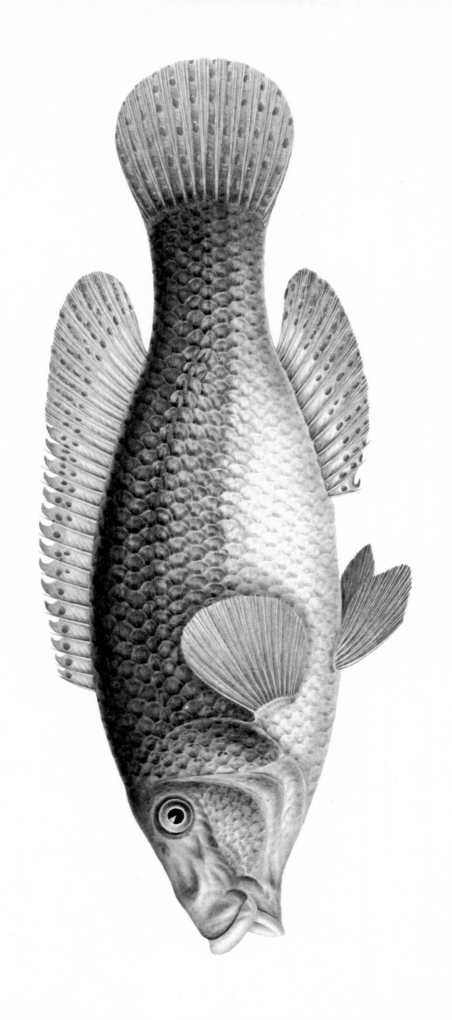

Carp
(Cyprinus carpio)

The Carp is one of the most widely distributed freshwater fishes. It is a native of Asia and has been introduced into Europe, presumably by monks who kept these fishes in the monastery gardens in the twelfth century. It has also been introduced to North America and other parts of the world. In China and Japan it has been the object of selective breeding for a thousand years, which has resulted in some very varied colour-mutations – for example, yellow, reddish and albino. The scales may be reduced in number or have sometimes even disappeared altogether (Mirror Carp, Leather Carp, and others). By breeding resistant strains it has been possible to farm Carp almost to the Arctic Circle and under tropical conditions. A few years ago a scaleless variety was found in Ethiopia, believed to have been taken there by the Italians in 1942.

Carp like calm, deep water. They eat almost anything and the strong teeth with which their pharynx is provided enable them to crush hard and bulky food substances.

The Carp's growth is rapid, and for this reason the fish is the object of intensive breeding in pools and ponds. Its life-span has been overestimated and is in fact rarely more than thirty years. It may grow to a large size. One individual of those introduced into America weighed 25 kilograms (55 pounds). The English record is 20 kilograms (44 pounds) but a Carp in South Africa achieved 40 kilograms (88 pounds).

In winter, Carp gather in shoals in deep water in lakes and ponds. Their metabolic rate drops sharply and they are said to hibernate. This is, however, not true hibernation, but winter torpidity.

Parchment in the French National
Museum of Natural History by an
anonymous painter. Vol. 93, no. 23.

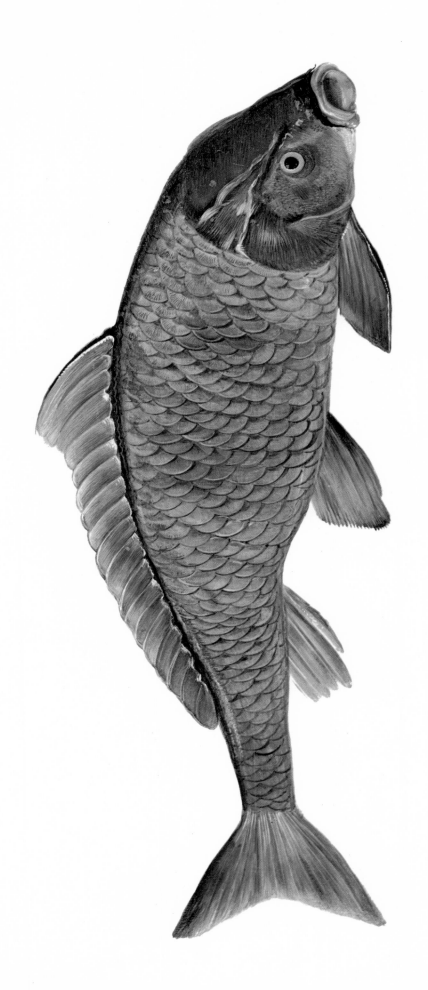

Garden Snail and Grove Snail

(Cepaea hortensis and *Cepaea nemoralis)*

The family of true snails (Helicidae) is astonishingly rich in species most of which look very similar, with a rather dull brownish hue. However, some have a brightly coloured shell, such as the little European snails *Cepaea hortensis* and *Cepaea nemoralis.*

In the plate on the facing page the miniaturist has depicted several colour varieties of these snails.

Two very common European species, the Garden Snail, which has been introduced into North America, and the Grove Snail, provide good examples of this variety which, in both species, shows itself in very similar ways. Their shells are of one colour, going from white and, most often, pure yellow, to pink, brown and even violet, or else decorated with from one to five longitudinal brown bands. This colour variation serves to camouflage each species in a number of habitats.

The general shape of the shell also varies as regards the height of the whorls and their contours.

Parchment in the French National
Museum of Natural History painted by
Jean-Gabriel Prêtre (1832?). Vol. 99,
no. 7.

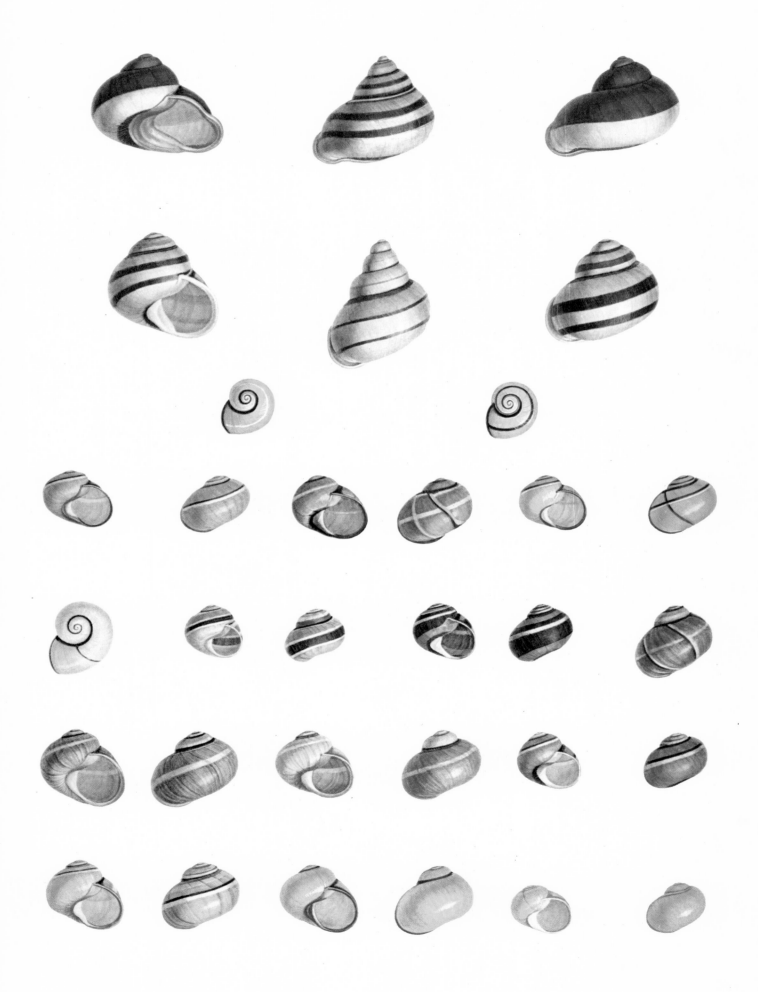

Hornet

(Vespa crabro) and its nest

The Hornet, which is the largest and most venomous of the European wasps, is a skilful builder. Its nest is constructed of paper which the insects make by chewing wood into pulp. It measures up to 30 centimetres (12 inches) in length by 15–18 centimetres (6–7 inches) at its maximum width, and is built in the hollows of rotting trees or haylofts.

The nest is built in spring by a queen Hornet which has been in hibernation. It is composed at first of from five to eight cells, attached to the wall of the cavity by a short pedicle, with the opening facing downwards. A thin leaf of papery substance envelops the tiers of cells. Pierced by small holes at the sides, it has its main opening near the bottom.

Shortly after they have been hatched the first workers demolish the papery envelope and replace it with a new one, which they add to as the number of cells increases. In the adult nest, the envelope is covered with thin sheets puffed up into irregular half-cylinders, opening from below and overlapping one another. Seen from outside the nest has a corrugated appearance. Inside, several tiers of cells, horizontally arranged and opening from below, are superimposed one on top of the other. Each layer of cells is attached to the one above by a pedicle or stalk. The oldest cells occupy the upper storeys, the largest and most recent form the lowest storey.

Parchment in the French National
Museum of Natural History painted in
the eighteenth century by an
anonymous artist. Vol. 80, no. 31.

Thorny oysters
(Spondylus)

The thorny oysters are among the most beautiful bivalve molluscs. Their shells bristle with long, ribboned flexuous spines. Their colours cover a rich variety of red from vermilion to softest pink.

They are undoubtedly pleasing to the eye when they are artistically arranged for a collector on the shelves of a display cabinet, but they reveal their beauty in its entirety only when living in their natural environment – the transparent, warm, motionless waters of a lagoon, mingling with madrepores in startling colours, with strange, multicoloured fish swimming around them.

Their valves are dissimilar. The thorny oyster rests on the right one which is heavier and more curved than the left one, and it is by this valve that it fastens itself to its support.

Although attached to the seabed the thorny oysters are not defenceless, for their spiny valves cause predators to keep their distance. Some, such as *Spondylus americanus*, secrete a toxic substance, an alkoloid similar to the muscarine of poisonous Amanitae, spondylotoxin, which releases a stench reminiscent of phosphuretted hydrogen.

Parchment in the French National Museum of Natural History painted by Jean-Gabriel Prêtre in 1843. Vol. 99, no. 6.

Grasshoppers
(Eumegalodon ensifer and *Eumegalodon blanchardi)*

The grasshopper illustrated above inhabits northern Borneo and the one below, the Indian Archipelago including Borneo. Virtually nothing is known about the habits and the habitat of these two orthopterous insects. The structure of their sword-shaped ovipositor (the individuals shown here are female), suggests that they lay their eggs in the soil in the manner of the Great Green Grasshopper (*Tettigonia viridissima*) of Europe.

Although it is usual to include in the general term 'grasshopper' all the jumping insects of this sort, the entomologist distinguishes between short-horned grasshoppers (and locusts) of the family Acrididae and the long-horned grasshoppers or bush crickets of the family Tettigoniidae. Briefly, the two families are characterized by the possession of short antennae and long antennae respectively. There are, however, many more differences between them.

Both kinds of insects stridulate, or 'sing', but whereas in the short-horned grasshoppers the sound is made by rubbing the hind legs against the forewings, the long-horned grasshoppers or bush crickets achieve the same end by rubbing the edges of the forewings together.

Another difference lies in the way the members of the two families lay their eggs. The female short-horned grasshoppers have a short ovipositor (egg-laying organ) and lay their eggs in pods. Female bush crickets have a long, blade-like ovipositor, nearly as long as, sometimes longer than, the abdomen. With this they lay their eggs singly in the soil or slit the stems of plants to deposit their eggs inside.

Parchment in the French National
Museum of Natural History painted by
Adolphe-Philippe Millot in 1890.
Vol. 85, no. 60.

Stony Coral

(Echinopora rosularia)

There are soft corals and stony corals. Among the latter are the reef-building corals. All corals belong to the phylum Cnidaria, together with sea-anemones, jellyfishes, and sea pens. One common name for all the cnidarians is nettle-animals because they are armed with microscopic stinging cells in their skin. With a few exceptions, the stings of cnidarians are quite innocuous so far as we are concerned. Certain jellyfishes, however, coming into contact with the human skin, can produce a pain rash which, in rare instances, has proved fatal. There is one kind of coral, known as the Stinging Coral, which also proves unpleasant when handled.

The true or stony corals may be divided into solitary and colonial corals. In solitary corals a single polyp, looking like a sea-anemone, lays down a limy skeleton beneath and around itself. The colonial corals consist of numerous polyps, like miniature sea-anemones, and live in company, connected to each other, and all contributing to the limy, or stony, skeleton supporting the colony.

Dead coral becomes white when the flesh covering it has decayed and disintegrated. In life, and while still covered with the flesh of the 'coral animals', as the polyps are often called, it may be brown, red, yellow and various shades of these colours.

Parchment in the French National
Museum of Natural History painted by
Paul-Louis Oudart in 1848. Vol. 76,
no. 89.

South American Owlet Moth
(Thysania agrippina)

Madam Maria Sybilla Merian lived in Surinam, where she had come with her daughter in 1699 to paint the gorgeous tropical butterflies. Madam Merian was descended from a family of artists, which included her grandfather, the engraver Johann Theodor de Bry, a Huguenot who had fled from Liège to Frankfurt. The talented Maria was a miniature painter with an intense interest in plants and insects. In Surinam she made sketches and notes of insects of South America, and after her death in 1701 these were published by her daughter in a book entitled *Insects of Surinam*.

It was in April 1700, in Surinam, that she painted this magnificent insect now known as the South American Owlet Moth. Her picture shows (top) the moth in flight and (left centre) settled on a leaf. The rest of the picture is devoted to the life history of the moth and shows a cluster of golden-yellow eggs, above these a caterpillar and between the two the silken cocoon enclosing the pupa.

Physania agrippina is only one of over 20000 species of owlet moths making up the family Noctuidae. Not all members of this family are large, some being less than a centimetre (0·4 inches) across the wings. Some of the owlet moths are brilliantly coloured and iridescent, but the great majority are soberly coloured and very hard to see when they settle on bark. All fly by night, the adults having a long tongue which is used for feeding on nectar, the juices of over-ripe fruit or sap.

Watercolour painted by Maria Sybilla Merian and taken from the work *Over de Voorteeling en Wonderbaerlyke. Veranderingen der Surinamemsche Insecten*, Amsterdam, 1719.

Seychelles Starfish

(Pentaceros (Oreaster) hiulcus)

This fine starfish thrives in the warm waters of the Indian Ocean which bathe the Seychelles Islands. Its central disc and its arms are thick, flat on the under surface and curved on the upper surface. The upper surface of each arm rises up in a prominent keel, ornamented with regularly spaced nodules.

On the under surface of each arm of starfishes is a groove, running from the mouth at the centre to the tip of the arm. This ambulatory groove encloses rows of tube-feet, used by the starfish for loco-motion, for clinging to rock surfaces or for holding prey, for each tube-foot is a tiny sucker. If one puts a live starfish on one's hand it is possible to feel the grip exercised by the tube-feet.

In the view of the under surface of the Seychelles starfish shown here (lower) the upper three ambulatory grooves show the rows of holes through which, in life, the tube-feet protruded. Inside the body and arms of the starfish is a system of tubes and small water bags (vesicles) forming what is called the water-vascular system, a sort of intricate hydraulic system. The tube-feet are part of this system. This means that the tube-feet can be protruded and with-drawn under the combination of muscular action and water pressure, and the movements of the tube-feet are coordinated by it.

Parchment in the French National Museum of Natural History painted by Paul-Louis Oudart in 1851. Vol. 101, no. 10.

Lantern flies and Cicadas
(*Laternaria* and Cicadidae)

The fauna of South America, especially the Amazon region and Guyana, is extraordinarily rich in insects. Sybilla Merian painted some wonderful examples of these, as shown by this plate in which lantern flies are placed side by side with cicadas, which are both members of the order Hemiptera.

The lantern flies have been the source of many legends. They are called lantern flies since at one time they were thought to be luminescent, although in fact they display no luminosity. Their head is surmounted by an enormous, coloured prolongation, giving it a very strange outline, so that it looks like a peanut. In flight these brightly coloured insects resemble butterflies. Very little is known about their habits.

The cicadas, with numerous genera and even more numerous species, have almost all the same mode of existence. Their larvae, whose front legs are bent in the form of hooks, dig underground galleries and, with their buccal stylets, pierce the skin of roots and suck their sap. Growth lasts for up to seventeen years. When it is nearly ended the larvae emerge from the earth, crawl up trees and shrubs, and become motionless. Their cuticle then splits down the back and the adult insect breaks free from it and flies away.

Watercolour painted by Maria Sybilla Merian and taken from the work *Over de Voorteeling en Wonderbaerlyke. Veranderingen der Surinamemsche Insecten,* Amsterdam, 1719.

Diadem Sea-urchin
(Phyllacanthus imperialis)

This species is among the most beautiful of the regular sea-urchins, which display their radial symmetry not only by the arrangement of the plates of their test, but also by the ten rows of their long spines. The lower ends of these spines engage on rounded knobs in a sort of ball-and-socket joint, and muscles enable them to be turned in all directions. They serve as locomotory organs, for by moving them in a coordinated manner the sea-urchin can walk and can even roll back into its normal position when it has fallen over.

The Cidaridae, the family to which this species belongs, are found in all seas, but they are most abundant in warm waters and on coral reefs. Their food consists of animals; they 'browse' sponges, horny corals and some madrepores. Most regular sea-urchins browse seaweeds and all feed with the aid of five teeth set in the mouth which is situated at the centre of the underside of the body. These teeth are supported by twenty pieces, also made of calcite, and are worked by muscles, the whole making up what is called the jaw apparatus. It looks like an old-fashioned lantern and has been nicknamed Aristotle's lantern after the Greek scholar, who was the first to make a close study of sea-urchins, 2000 years ago.

The species of *Phyllacanthus* are found in the Indo-Pacific waters, particularly off the coast of Australia.

Sea-urchins are so named for their coat of spines. The ancient name for a hedgehog was urchin and the similarity in the coat of spines was responsible for the name given to this marine animal.

Parchment in the French National
Museum of Natural History painted by
Dickmann in 1849. Vol. 101, no. 8.

Harlequin Beetle
and Longicorn Beetle
(Acrocinus longimanus and *Macrodontia cervicornis)*

These two very fine beetles of the family Cerambycidae are noteworthy both for their sexual dimorphism and their great size.

The Acrociu, Forest Harlequin or Cayenne Harlequin lives in South America. It is quite common in Brazil where its larvae bore through the wood of various trees of the forest, such as fig trees (*Ficus*), *Lonchocarpus sprucearus*, *Arctocarpus* and *Chorisia*. The male, shown here bottom left, is distinguished from the female by the excessive size of its fore legs which are as long as the antennae. Nothing is known about the function of these appendages.

The Longicorn (*Macrodontia*) has a less elaborate sexual dimorphism. The individual shown here is a female and its mandibles, although large, are much less strong and much smaller than those of the male (4 centimetres, 1·5 inches long). It is to them that this insect owes its specific name for their supposed resemblance to the antlers of a stag. Its colouring acts as a very effective camouflage for it blends in with the bark, twigs and leaves on which it can usually be found. The larvae of *Macrodontia* live in the wood of a variety of trees in the Amazon region, the homeland of so many giant insects, and in Guyana.

The two little insects shown on this plate are also Longicorn beetles, probably Prioninae, but the species cannot be identified with certainty.

Watercolour from Rösel von
Rosenhof's work: *Der monatlich
herausgegebenen Isekten Belustigungen.*
Vol. II, plate 1. Nuremberg, 1746.

Elephant-ear Sponge
(Spongia officinalis)

There are some 3000 species of sponges, most of which live in the sea. Only a small percentage live in fresh water. The bulk of these 3000 species have skeletons of calcite or silica. A small proportion have fibrous skeletons of spongin or keratin, a substance chemically related to silk. From among these are a few species that are commercially valuable and are spoken of as commercial sponges or bath sponges.

The best quality commercial sponges are found in the Mediterranean, and especially the eastern Mediterranean. The finest of these are known commercially as the Fine Turkey Solid, the Fine Turkey Cup and the Elephant-ear. The only difference between these three is shape; the Turkey Solid is a rounded mass, the Turkey Cup is cup-shaped and the Elephant-ear is the Turkey cup grown large.

Although we speak broadly of bath sponges, the use of the natural article for toilet purposes has been largely superseded, but their use for other purposes still continues. The Turkey Solid and Turkey Cup were always prized as bath sponges proper, because of their fine texture, but a large Elephant-ear Sponge, funnel-shaped and standing perhaps 0·6 metre (2 feet) high, or like a flattened funnel and nearly 1·2 metre (4 feet) across, would have been unmanageable in the bath, so it was put to a variety of other uses.

Once it was coveted and used, by those who could afford it, as a lining for the saddles of hunters, ideal for soaking up sweat as well as obviating chafing of the horse's skin. When walking sticks were *de rigueur* for gentlemen many were highly polished, using strips of it.

Parchment in the French National Museum of Natural History painted by Juliette Alberti on 3 March 1851. Vol. 76, no. 6.